IMAGES
of America

EARLY BEAUMONT

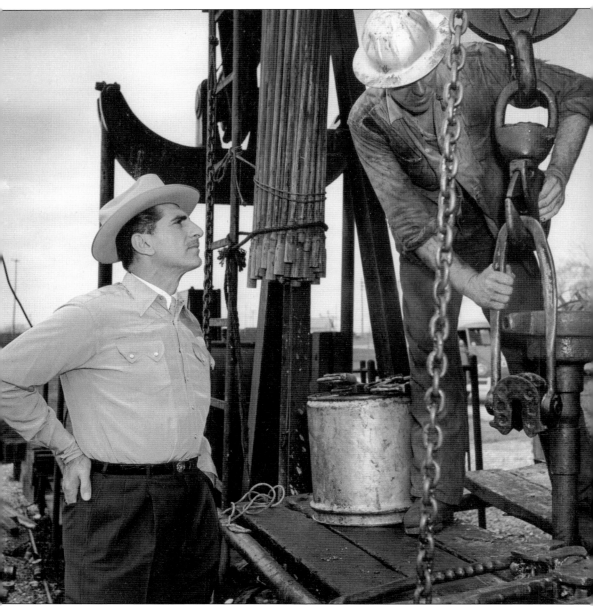

Michel Halbouty (left), born in Beaumont, graduated with master's degrees in geology and petroleum engineering at Texas A&M because he was captivated with the mystique of Spindletop. He later experienced the second boom of the Yount-Lee Oil Company, discovering oil in 1931. Halbouty went on to become one of the most successful wildcatters and most respected oilmen in history. (Courtesy of Michel Halbouty Hewitt, Halbouty family collection.)

ON THE COVER: This is a 1910 photograph of workers at the famous Spindletop oil field. The full image appears on page 81. (Courtesy of Tyrrell Historical Library.)

IMAGES
of America
EARLY BEAUMONT

Rob Blain

To Tony with God love I appreciate for ll you doin chat and your love of His Church. Rob Blain

Romans 15:13

ARCADIA
PUBLISHING

Copyright © 2014 by Rob Blain
ISBN 978-1-4671-3195-7

Published by Arcadia Publishing
Charleston, South Carolina

Printed in the United States of America

Library of Congress Control Number: 2013957656

For all general information, please contact Arcadia Publishing:
Telephone 843-853-2070
Fax 843-853-0044
E-mail sales@arcadiapublishing.com
For customer service and orders:
Toll-Free 1-888-313-2665

Visit us on the Internet at www.arcadiapublishing.com

CONTENTS

ACKNOWLEDGMENTS

Working on the life story of my grandmother, a godly woman who grew up in society in Savannah, Georgia, and came to frontier Texas in support of her husband in 1899, a friend, Molly Mills, saw the manuscript and said I needed pictures to show where the wonders of her life happened in Beaumont. That led to the discovery of Arcadia Publishing's Images of America series and my inquiry to them. Their interest in my focus brought about this book.

The adventurous process of writing a book and, in this case, collecting photographs of a specific era took me to places and introduced me to wonderful people I would never have known. My niece, Joyce Blain, knows Beaumont history and was my good right hand getting everything done for the first several months of work, making connections with television stations for the public "call for pictures" and sharing both her knowledge and ability to make things happen. Well-known historian and local maven Judith Linsley helped me in many ways and introduced me to many people. She and former mayor Evelyn Lord both encouraged and led me to the right people. The call for pictures garnered contacts with many Beaumonters who had photographs not yet seen by the public at large.

Ryan Smith, executive director of the Texas Energy Museum in Beaumont, has great ideas, knowledge of his subject areas, and many connections throughout the area.

Glenn Cummings quickly became a friend and got me started with enthusiasm for my mission and introductions to people with collections of pictures taken in Beaumont. After Glenn, I met Paul Eddy and Bill Grace at the Tyrrell Historical Library, which has many collections of family photographs and complete collections spanning every aspect of life and commerce in the area. Archivist Stephanie Soule was invaluable in finding things and is dedicated to every search and question a person has. All Tyrrell staff are wonderful and knowledgeable.

Becky Mason with the Beaumont Rotary Club and Robert Robertson, local historian, both supported my efforts with encouragement and suggestions that proved valuable.

Darlene Mott is the front line of information, a treasure of finding things at the Sam Houston Regional Library in Liberty, Texas, and is backed up by Lisa Meisch, archivist, and museum curator Alana Inman makes everything happen.

Penny Clark, archivist at Lamar University's Special Collections, is a wonder of ideas and resources related to Beaumont's past, present, and future both for Lamar's collections and for other sources.

Paul Spellman, author and historian, helped identify sources and photographs.

My friend Kip Krause referred me to his beloved Lynn, who taught me how to edit photographs with the little built-in picture editor in my computer.

Joe Pase with the Texas Forest Service at Lufkin found resources related to forestry and lumbering in East Texas.

Jerry Frazee wrote a book about the Fabulous Heywood Brothers, who came to Beaumont after the Lucas gusher and made many successful discoveries, contributing much to Texas, Louisiana, California, and Alaska. Frazee helped with consultations on the brothers' lives and work.

The family of Michel Halbouty, famous wildcatter, geologist, and oil man, were all helpful in looking for early pictures of him. Especially helpful were Linda Halbouty, Michel Halbouty Hewitt, and Shyrrel Stevens, daughter of Halbouty's wife Billye Stevens Halbouty.

Gene McFaddin is the wit who looked up compiled information on the "Shark Bench" his father is pictured sitting on in chapter four.

It may sound like all fun and joy meeting people, finding unexpected treasures, and working to put it all together, but doubts set in and discouragement made me wonder if it would happen. That is where the encouragement from my wife Martha, other friends, and the prayer team at our church kicked in and spurred me on my way with the Spirit leading.

Thanksgiving to all is not enough! The Lord, life, and living are good in Beaumont!

FOREWORD

Every city has a distinct personality, and Beaumont is no exception. Born over 175 years ago as a tiny settlement at the intersection of the Neches River and the Opelousas Trail, it has prospered during lumber and oil booms and survived wars and depressions. Beaumont is a special place to those who live there, of course, but its story is a fascinating one to outsiders as well.

Author Rob Blain is a native Beaumonter, three generations strong. His grandparents, Jim and Sallie Blain, owned the French Market Grocery in Beaumont in 1901, when the Spindletop oil boom began. They experienced that world-changing moment first-hand and knew the principals. In fact, Sallie recorded in her memoirs that Anthony Lucas, who drilled the famous Lucas gusher, was in their store when he received the news of his gusher and borrowed her husband's horse to dash out and see what had happened.

Though Rob now lives elsewhere, he has figuratively (as well as physically) returned to Beaumont to write this book; his affection for his former home is apparent in the finished product. He has chosen to capture an especially rich period in Beaumont's history; not just rich in the economical sense because of the lumber and oil booms that took place, but also rich in cultural changes and population diversity.

His meticulous and tireless research has unearthed a treasure trove of pictorial information. The old adage that "one picture is worth a thousand words" is nowhere more true than in recreating history. Photographs not only provide vivid and irrefutable documentation, date by date, but evoke the intangible—the feel of a place—as well.

Over the years, various histories of Beaumont have been written, each with a different focus, but there is always room for one more. This volume brings its own perspective and will now become an essential part of the collection. Beaumonters who are proud of their heritage can especially enjoy this newest chronicle of their town and be grateful to Rob. As a Beaumont historian and multi-generation Beaumonter, I most assuredly am.

<div align="right">

Judith Walker Linsley
Beaumont, Texas
December 9, 2013

</div>

Linsley is the author of *Giant Under the Hill*; *Beaumont, A Chronicle of Promise*; *Historic Beaumont: An Illustrated History*; *The McFaddin-Ward House*; *Henry Milliard, Forgotten Texian*; and other books and articles including those appearing in *Southwestern Historical Quarterly* and the *Texas Gulf Historical and Biographical Record*.

INTRODUCTION

Beaumont was settled between 1824 and 1870 on the thickly wooded banks of the Neches River. The few settlers there made a refuge for citizen-soldiers of the Texas independence battles and when independence was won at nearby San Jacinto in 1836, Beaumont's strategic importance as a port and lumber and agriculture center became better known.

By 1880, the town had begun to prosper as a lumber town with important, large sawmills and lesser ones, and railroads connecting the town to Houston, New Orleans, Kansas City, and other points. The population was about 2,500, and lumber was the original economic engine ultimately supplying millions of board feet of pine across the world with cattle and other agricultural products increasing commercial opportunities.

By 1900, the population was about 5,000, but a disaster struck the Gulf Coast in 1900: the Galveston Storm, a hurricane that essentially covered the island of Galveston with a storm surge of 15 feet, which completely decimated the entire island, causing the deaths of 8,000 to 12,000 people, the largest natural disaster in US history. Beaumonters immediately sent ice, food, supplies, and people to assist in the recovery. Many of the 37,000 citizens who survived relocated to Beaumont.

The event that brought Beaumont to the attention of the world, however, was the Lucas Oil gusher at Spindletop, which blew in on January 10, 1901. Whereas the world supply of oil had previously been measured in thousands of barrels, suddenly millions of barrels of oil were available and this discovery ushered in the machine age across the world.

According to history.com, Spindletop produced more than 3.5 million barrels of oil in its first year; in the second year, production rose to 17.4 million. "In addition to driving the price of oil down and destroying the previous monopoly held by John D. Rockefeller and Standard Oil, Spindletop ushered in a new era in Texas-based industry, and was enormously influential in the state's future development."

Spindletop created many companies like Humble Oil, which became Exxon, Gulf Oil, Texaco, and others. These and other companies brought workers and families into the area, along with fortune seekers.

From 1901 through 1910, flowing oil enabled the building of mansions and gracious homes because of the flood of innovative people and the money accompanying their ventures. Pictures of the homes, buildings, and people of this era are enchanting.

The 1920s saw continued development of oil, agriculture, and commerce in the Beaumont area, and in 1925, two venturers thought there was still oil on the flanks of Spindletop hill and succeeded in bringing in a second oil boom with wells that produced more than the original discoveries. This second boom, along with its supporting industries and businesses, caused more growth.

New buildings and the growing economy of the second boom helped the community through the 1920s into the 1930s, but the Great Depression affected everyone and everything. Tough times bring out both the worst and the best in people, and the entrepreneur who spearheaded the second discovery, Miles Frank Yount, exhibited the best when he stepped up and personally gave two loans to the City of Beaumont to pay its employees. Some months later, the loans were repaid, but within the year Yount suffered a heart attack and died.

Beaumont continues as a place of grace and energy and is home to many who understand the history of "a single town that boomed three times in the same century, first with timber and then twice with oil," as described by Joyce Blain. The greatest boom, however, could be called the people who came to Beaumont to find, use, and thrive in the opportunities rich in the area: lumber, agriculture, oil, and their own spunk and human ingenuity.

One

THE 1880s (AND BEFORE)

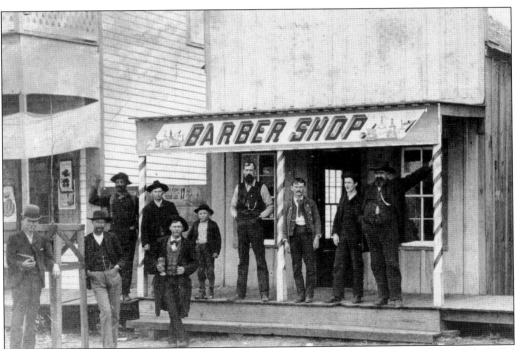

At this Beaumont frontier town barbershop, the men identified standing in front include Ed Ogden (seventh from the left), S.E. McCarty (eighth from the left, leaning against middle post), and blacksmith J.D. Goodwin (far right). Illustrated on the sign above them are bottles, shaving cups, and a straight razor. (Courtesy of Tyrrell Historical Library.)

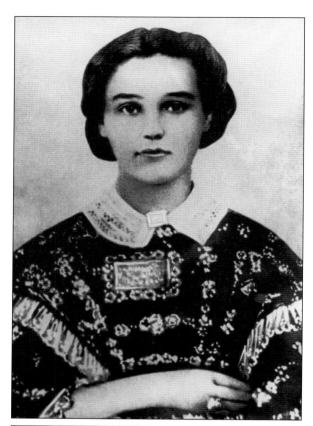

Beaumont pioneer Mary Azema Hebert is shown in about 1870. She lost her husband, Eloi Broussard, to fever in 1868 and remarried about 1873 to Lovan Hamshire, for whom the nearby town of Hamshire is named. (Courtesy of Tyrrell Historical Library.)

The steamboat *Laura* plied the waters around Beaumont from about 1875 to the 1880s, according to historian W.T. Block Jr. (Courtesy of Tyrrell Historical Library.)

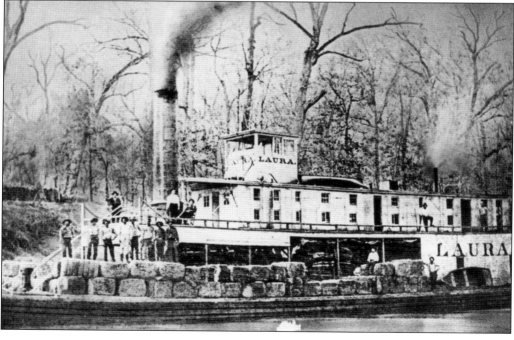

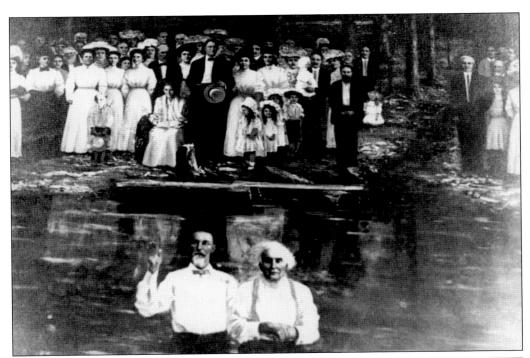

In this picture, titled "A Good Old Fashioned Baptizing," the man in the crowd holding the hat is John Henry Kirby, a leading lumberman and industrialist. His father, John Thomas Kirby, is the white-haired man being baptized, and the preacher is Sam Man. This is a copy of a painting by a German artist. (Courtesy of the Tyrrell Historical Library, John Walker collection.)

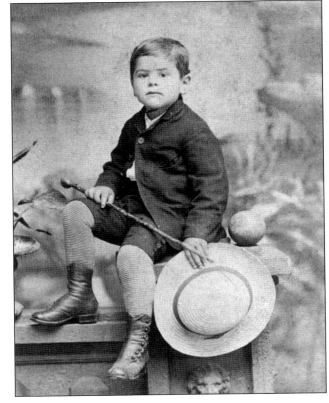

Ed Broussard Hebert, son of J.M. and Effie Hebert, had four siblings—two older and two younger. He grew up to marry Grace Fae Dutton, who was referred to as "Gracia" on her tombstone. He was known as an oilman, farmer, cattleman, and rancher. The couple attended St. Anthony's Catholic Church and lived into the 1940s. (Courtesy of Tyrrell Historical Library.)

The caption under this newspaper picture of Alice Carroll read, "Shy bride to be was Alice Carroll who, on the eve of her marriage in 1882 to a successful young Jefferson County lumberman named J. Frank Keith, had this picture made as a parting memento for papa and mama, the Frank W. Carrolls. Now a venerable 93, the winsome bride of '82 has become, by virtue of quietly forceful leadership in the city's charitable and religious life spread over three-quarters of a century, one of Beaumont's best loved citizens. This charming and hitherto unpublished portrait of her mother was loaned to the Jubilee edition by Mrs. Cecil Easley, 615 Fifth Street." Additional notes say, "In the 1930s she drove an electric automobile-the only electric auto in Beaumont, and she lived at Calder and Sixth, NW corner." (Courtesy of Tyrrell Historical Library.)

Stephen Chenault, from nearby Orange, Texas, is seen in his Civil War uniform in 1869. He became a steamboat owner and part-time captain and was also a lawyer as well as being involved in many businesses. (Courtesy Tyrrell Historical Library.)

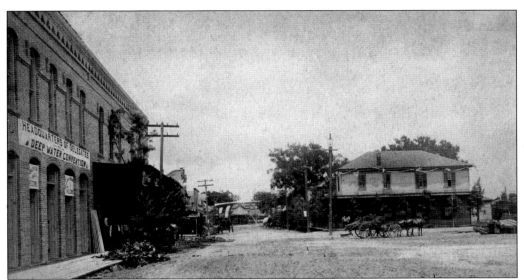

Preparations are made at the corner of Pearl and Crockett Streets in 1889, just prior to the Deep Water Convention. On the left is the A.F. Goodhue Building with a banner reading, "Headquarters of Delegates to Deep Water Convention." The New Birmingham Deep Water Convention was held July 16 and 17 in 1889. Beneath the banner, two signs read, "Convention Hall Welcome," and "Convention Room Welcome," respectively. Boughs of pine trees are being used presumably for convention hall decoration. Near the horse-drawn carriage are three men, and to the far right is a locomotive. (Courtesy of Tyrrell Historical Library.)

William L. "Bill" Rigsby was the first city secretary of Beaumont in 1881 when the city reincorporated. He was tax assessor-collector of Jefferson County from 1869 to 1881, and secretary for the City of Beaumont from 1881 to 1887. He died in 1900. (Courtesy of Tyrrell Historical Library.)

Pictured here in 1874 is W.P.H. McFaddin wearing his Texas Military Academy uniform in Austin. McFaddin and his family established land interests of about 150,000 acres, plus rice and, later, oil and other interests. The Spindletop oil discovery was made on McFaddin land. (Courtesy of Tyrrell Historical Library.)

Mrs. Mixson, seen here in the 1850s, may be the mother of Underhill Mixon, a local beauty who married George Carroll. Carroll was one of the original backers of Patillo Higgins in finding oil on Spindletop Hill, the event that changed the world and enabled modern transportation. (Courtesy of Tyrrell Historical Library.)

Col. Henry Millard, seen here around 1843, was one of the original founders of Beaumont and named the town for his wife's family. Millard was present at the Battle of San Jacinto, in which Texas won its freedom from Mexico. He was given Gen. Santa Ana's dueling pistols, which he passed on to his descendants. (Courtesy of Tyrrell Historical Library.)

These log rafts, sitting in the Neches River about 1879 with the steamboat *Laura* in the background, were floated to the sawmills in Beaumont to be processed for usable lumber and material. Three men stand at center, and three others are on the left on the logs. (Courtesy of Tyrrell Historical Library.)

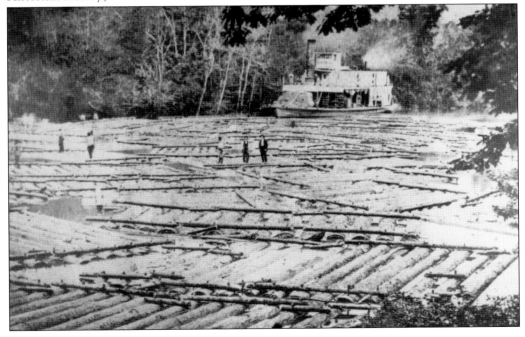

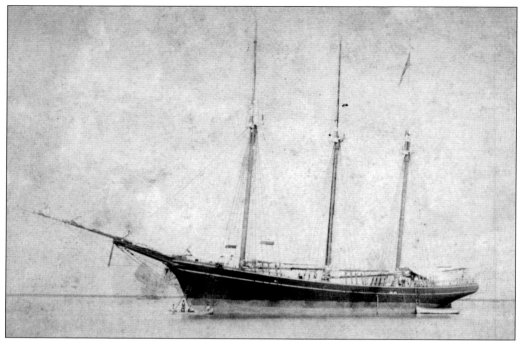

The schooner *Alice Archer*, with Capt. Arthur Gibbs of Bath, Maine, arrived at Sabine near Beaumont on October 12, 1890, to load lumber from Beaumont and Orange. The ship weighed 447 tons and had a lumber capacity of 450,000 board feet. The payload was bound for Greytown, Nicaragua. (Courtesy of Tyrrell Historical Library.)

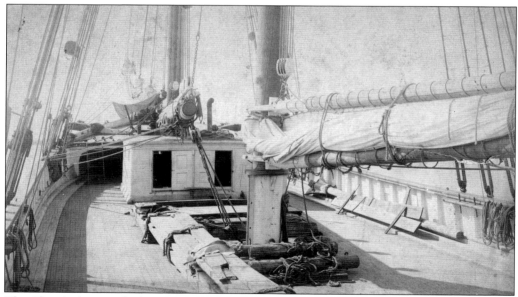

The *Alice Archer* was the largest oceangoing vessel at the time to come into the area. This closer look at her deck shows ample room to transport lumber or other materials. (Courtesy of Tyrrell Historical Library.)

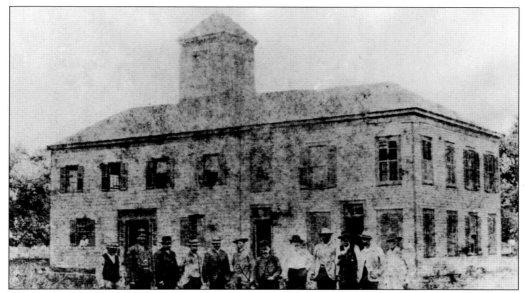

The original Jefferson County Courthouse in Beaumont was built in 1855. On the first floor in this newly built courthouse, the First Baptist Church of Beaumont was most likely established. On the far right in this picture, which comes from the Rosa Dieu Crenshaw family, is Rev. John Fletcher Pipkin, who worked closely with J.M. Long before the Baptists organized their own church. The building consisted of a jury room, jail, and county clerk and sheriff offices on the first floor, with a large courtroom on the second. (Courtesy of Tyrrell Historical Library.)

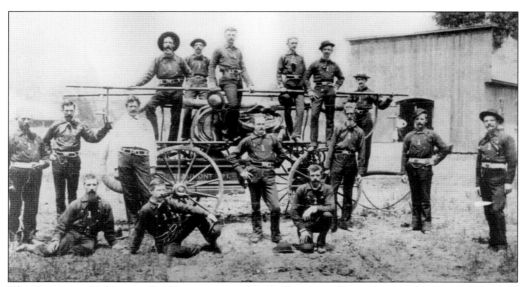

The Beaumont Volunteer Fire Department of 1882 illustrates the readiness of citizens to respond to fire. (Courtesy of Tyrrell Historical Library.)

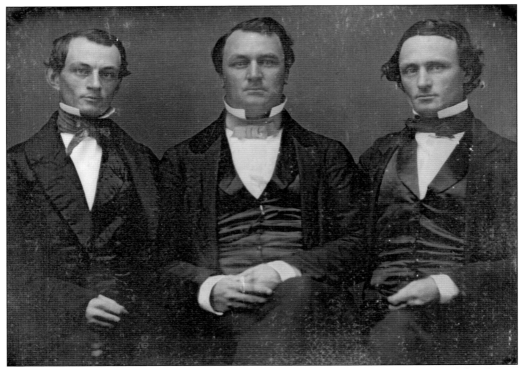

This 1850 daguerreotype of the three Gilbert brothers, from left to right, Elias, Smythe, and Nathan, shows them stylishly dressed. The Gilberts were early pioneer merchants and real estate holders; they became prominent in lumber, petroleum, banking, ranching enterprises, and civic developments. (Courtesy of Tyrrell Historical Library.)

This original picture of Annie Wilburger Gilbert, taken about 1885, bears the inscription, "My Mother." (Courtesy of Tyrrell Historical Library.)

Mrs. Charles D. Smith shows the beautiful styles of the Victorian era in her dress of 1880. (Courtesy of Tyrrell Historical Library.)

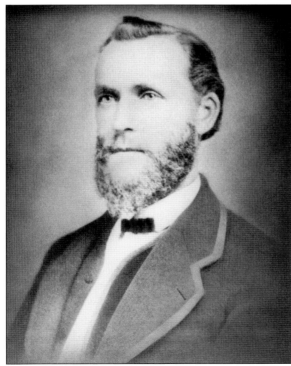

John C. Craig, who moved to Beaumont from Sabine Pass, was a businessman and merchant and the first mayor of the reincorporated Beaumont from 1881 through 1882. (Courtesy of Tyrrell Historical Library.)

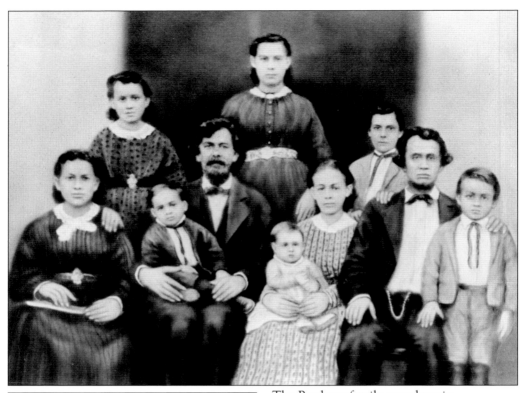

The Bordages family, seen here in 1869, produced cattlemen, rice farmers, storekeepers, bankers, and county officials. From left to right are (seated) Artemise Barus, Isadore R. Bordages, Jean Pierre Barus, Mary Bell Bordages, Ellen Elliot Bordages, and Phillippe Bordages; (standing) Elvira Jane Barus, Josephine Barus, and John M. Barus. (Courtesy of Tyrrell Historical Library.)

Byrd Blanche "Byrdie" Goodman (left) poses with another young girl, perhaps a sister. Byrdie later married Rudolph Charles "R.C." Miller. (Courtesy of Tyrrell Historical Library.)

Two

THE 1890s

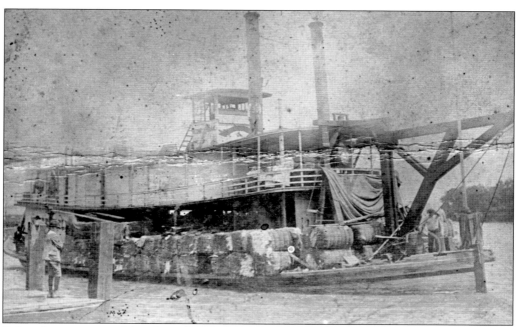

Bales of cotton were shipped on the *Neches Belle* steam-powered paddle wheeler at the Fourth Street dock in Orange, Texas, 26 miles from Beaumont. A caption on the back of this photograph reads, "Picture would have to be approximately 1890. The features on the boat are recognized from other pictures of the Neches Belle." (Courtesy of Tyrrell Historical Library.)

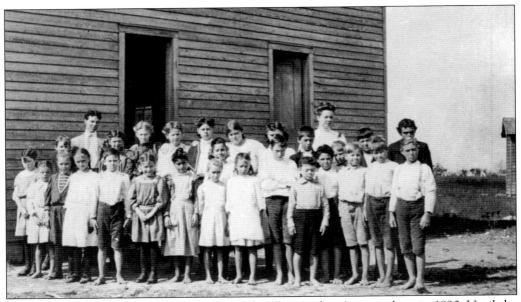

The first South Park School (and some of its barefoot students) is seen here in 1890. Until the middle of the 20th century, many students attended school and went most places sans shoes. (Courtesy of Tyrrell Historical Library.)

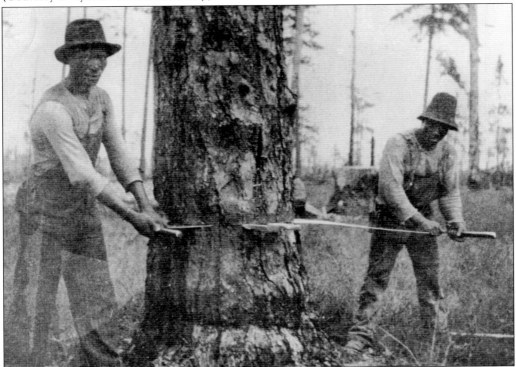

Lumbermen with a crosscut saw fell a large pine. The tremendous longleaf pine forests to the north gave Beaumont its basic industry from the mid-1880s through the 1890s. (Courtesy of Tyrrell Historical Library.)

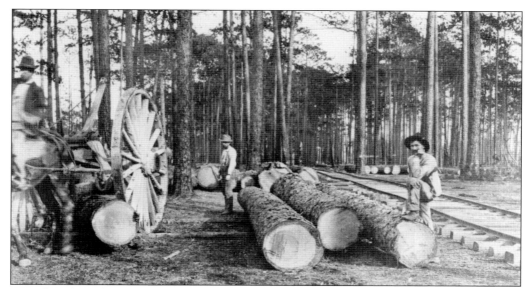

Large logs from the pine forests that gave Beaumont its first economic boost are hauled by cart to be loaded onto railcars in the 1890s. Pine trees from the area were used to rebuild the nation after the Civil War when other sources had been depleted in the East and South. (Courtesy of Tyrrell Historical Library.)

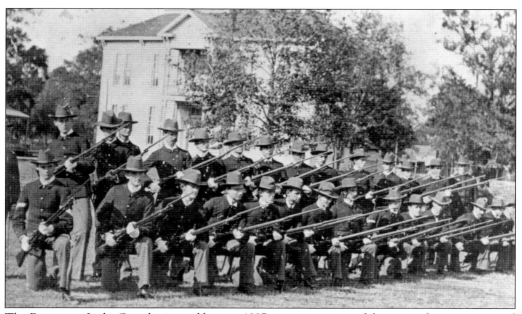

The Beaumont Light Guard, pictured here in 1897, was a carryover of the original minutemen and the units formed of local men when arms were called for. (Courtesy of Tyrrell Historical Library.)

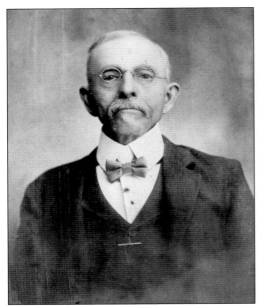

John J. French Jr. and his wife, Francis Cox French, seen here about 1890, remained in Beaumont. However, John's father, the original settler, moved to the Texas Hill Country because life in Beaumont became "too fast." (Courtesy of Tyrrell Historical Library.)

Charles Stroeck and Novaline Baldwin were married in 1897. Stroeck came to Beaumont as a youth around 1880 and became a licensed druggist and soon a bookkeeper at First National Bank of Beaumont, where, as a hard worker, he was eventually elevated to president, guiding the bank through the Depression until 1937. Baldwin was president of the YWCA and active with other civic organizations, including the Colonial Dames of America, Daughters of the American Revolution, and the United Daughters of the Confederacy. (Courtesy of Tyrrell Historical Library.)

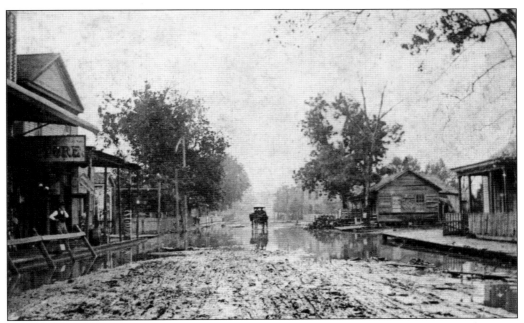

As any Beaumonter knows, and as the mud on flooded Pearl Street seen here in 1890 can attest, heavy rains can cause problems. In the days before paved streets, the rains caused flooding and mud everywhere. (Courtesy of Tyrrell Historical Library.)

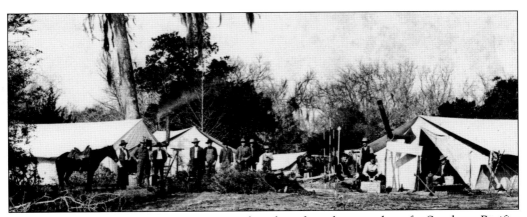

These men at a surveying camp in 1890 are thought to have been working for Southern Pacific. They had quite a camp, likely near the banks of the Neches River, and their equipment includes large tents with stoves, horses, mules, and surveying equipment with poles, visible at center. (Courtesy of Tyrrell Historical Library.)

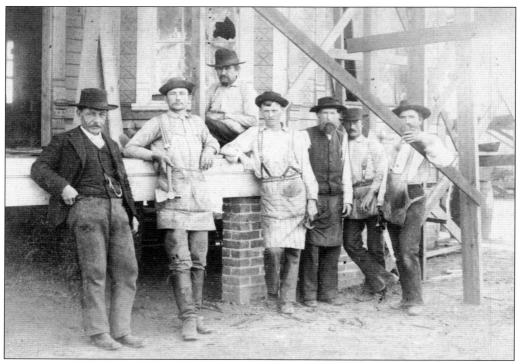

Four of these carpenters are Jim Ory, Ed Van Wormer, Bart Wilderson, and Simpson B. Stevenson. (Courtesy of Tyrrell Historical Library.)

These schoolchildren were photographed by Robert Keith. Identified are Vol McFaddin (second row, second from the left) and Sammy Wilson (second row, far right). (Courtesy of Tyrrell Historical Library.)

This is a Woman's Christian Temperance Union picture of Emily Underhill (Mixson) Carroll, who married George Carroll in 1877. Carroll came to Beaumont in 1873 and founded Beaumont Lumber Company, and became partner in the Gladys City Oil, Gas, and Manufacturing Company. Their 1877 wedding was the first to be held in the Methodist Baptist Church on Main and Fannin Streets. Carroll was a strict prohibitionist and went on many raids to uncover illegal drinking. He helped organize the First Baptist Church of Beaumont and assisted with the construction of the YMCA building. (Courtesy of Tyrrell Historical Library.)

The North End School was completed in April 1890 and was also known as the Main-Calder building. This wooden building was later replaced by a brick structure, which was called the Millard School and stood near St. Mark's Episcopal Church. One historian says the North End wooden building was then moved to Pine Street and became the Pipkin School. (Courtesy of Tyrrell Historical Library.)

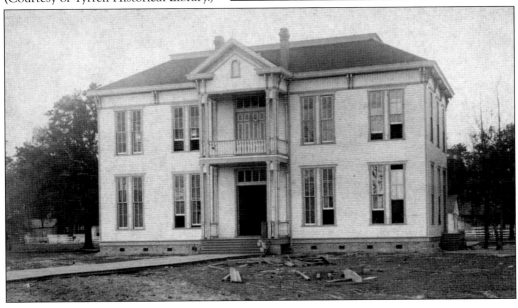

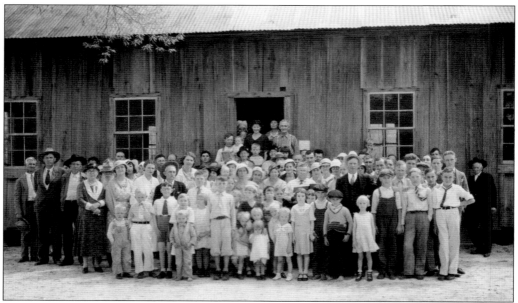

Schoolchildren are shown with their teacher Katie Land, at rear center in dark clothing. The caption at the bottom of the picture reads, "Miss Katie Land taught in this one-room school in the 1880s where Beaumont City Hall now stands. Private schools were widely scattered in the days before the founding of public schools." The reference to Beaumont City Hall refers to the time when it was located in the building currently known as the Julie Rogers Theater, at 765 Pearl Street. (Courtesy of Tyrrell Historical Library.)

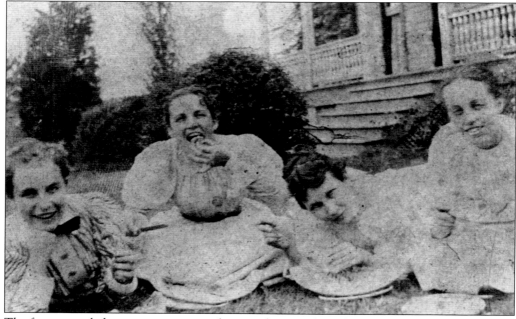

The four young ladies enjoying watermelon on a lawn in this July 1897 photograph may include Edith Fuller Chambers (second from left), the mother of Florence and Rugh Chambers. (Courtesy of Tyrrell Historical Library.)

Anna Elizabeth Kidd was married to one of Beaumont's first successful merchants, Christopher Columbus Caswell. (Courtesy of Tyrrell Historical Library.)

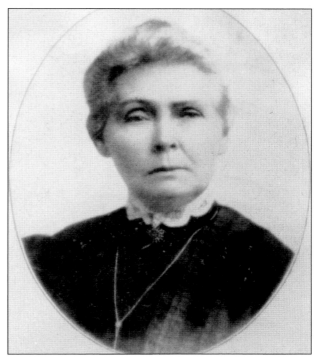

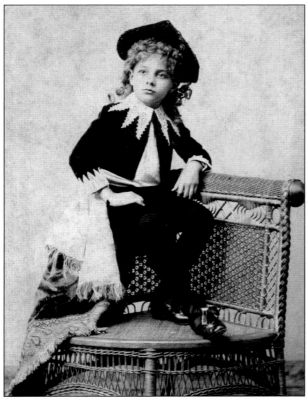

Young Harry Jirou poses on a chair. Jirou was a lifelong resident of Beaumont, a certified public accountant who engaged in real estate and served as an executive secretary of the Community Chest for 12 years. He was also an avid photographer who took many of the now historical photographs of early Spindletop, as well as a prominent Boy Scout leader and one of the few to receive the Scoutmaster's Key for outstanding work in all fields of scout activities. In 1929, he was a leader of a group of 16 scouts from Beaumont who attended the World Jamboree of Scouts in Birkenhead, England. (Courtesy of Tyrrell Historical Library.)

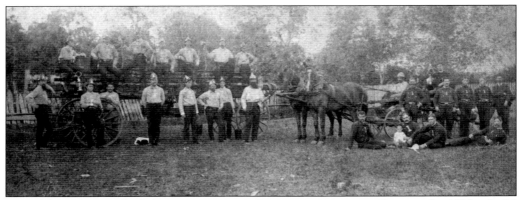

Two of the volunteer firefighting companies in Beaumont are pictured here in the 1880s: the V. Wiess Hook and Ladder Company (left) and the Beaumont Fire Company No. 1. There are 16 men with a hook and ladder truck on the left side. On the right are 12 men and a baby in front of a horse-drawn fire wagon; almost all of the men have a large "1" on their clothing. The Wiess Hook and Ladder Company was formed in 1887 and named for Valentine Wiess, a prominent local lumberman and merchant. The Beaumont Fire Company No. 1 was organized by E.L. "Ed" Wilson and officially created on December 19, 1881. It consisted of 16 volunteer firefighters. (Courtesy of Tyrrell Historical Library.)

A man is being pulled on a mud sled on a Beaumont street. Mud sleds were seen in the 1880s to 1910s, as streets and roads were not yet paved. (Courtesy of Tyrrell Historical Library.)

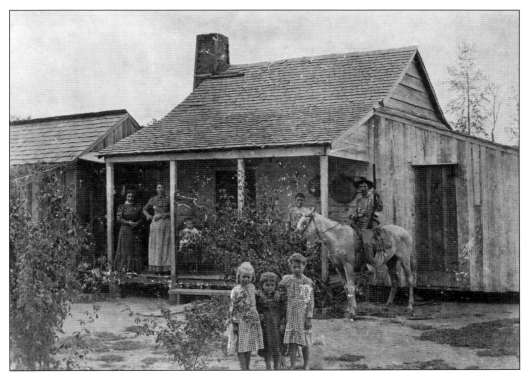

In Beaumont, each small house had a porch for coolness. This home shows an addition on the right with an outside door. Five children—three girls in the foreground and a baby and a boy on the porch—along with two primly dressed women, a man on horseback with hunting weapons, and the outline of another man barely visible above the shoulder of the woman to the far left, are seen here in 1895. Written on the back of this photograph is this note: "In frontier times, each family member, even children, had certain tasks to perform. People had to learn to make things themselves when they lived far from towns." (Courtesy of Tyrrell Historical Library.)

A group of Beaumonters celebrates at Sabine Lake in 1894. From left to right are (first row) Vallie Fletcher, Carrie Bacon, and Henry Langham; (second row) Will Keith, Ethel Leany, Kate Fletcher, Marrion Fletcher, and Earl Wilson; (third row) Jim Keith. These young people were members of some of the best-known Beaumont families. (Courtesy of Tyrrell Historical Library.)

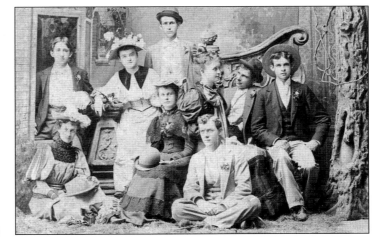

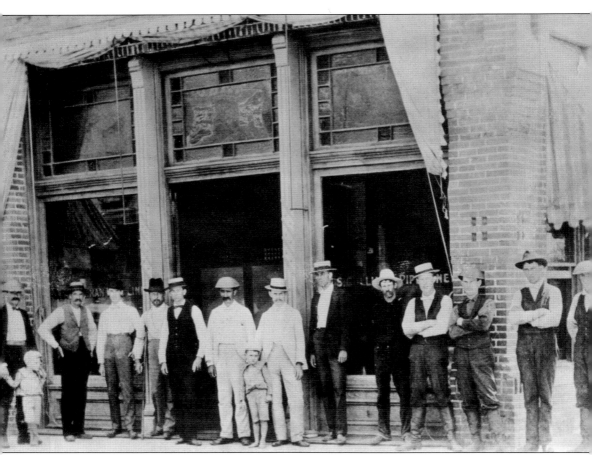

This historical photograph shows J.S. Cullinan with family members and associates while he was living and working in Corsicana in 1898. Cullinan had risen through the ranks at Standard Oil and then left that company when he was contacted by people in Corsicana, where oil had been found. He was a consultant and producer there, then formed the J.S. Cullinan Pipeline Company. He built the first refinery in Texas in Corsicana in 1898. His company is one of the entities that formed the Magnolia Petroleum Company, which became Mobil. Cullinan later formed the Texas Fuel Company, which became Texaco, in 1901 when oil was discovered at Spindletop. In this picture are family members and employees of J.S. Cullinan Pipeline Company at Corsicana, from left to right, J.S. Cullinan, Craig Cullinan (child), F.T. Whitehill, Dr. M.P. Cullinan, Willis C. Collier, W.H. Page, John Cullinan (child), W.C. Proctor, E.R. Brown, Dannee Buck, W.T. Cushing (builder of the Cullinan Pipeline), Frank Cullinan, Ed Loneget, and Frank Perfield. (Courtesy of Tyrrell Historical Library.)

The home of John C. Ward on Washington Street, now Gilbert Street, seen here in 1895, shows the "natural air-conditioning" of the time: large windows for cross ventilation as well as porches and large trees for shade. It was sold just three weeks before the Lucas gusher came in because the Kansas City Southern Railway had recently been put in on Washington Street in front of the house and Ward objected to the trains. (Courtesy of Tyrrell Historical Library.)

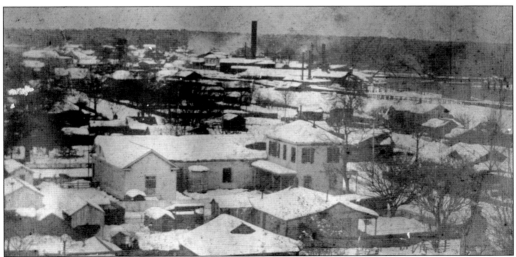

The caption on the back of this picture reads, "This snow picture was taken Feb. 15, 1895, from the top of the Courthouse looking toward Milam Street. Snow was 28 inches deep on the ground. The large wooden building in the foreground is the Beaumont Lumber Company." (Courtesy of Tyrrell Historical Library.)

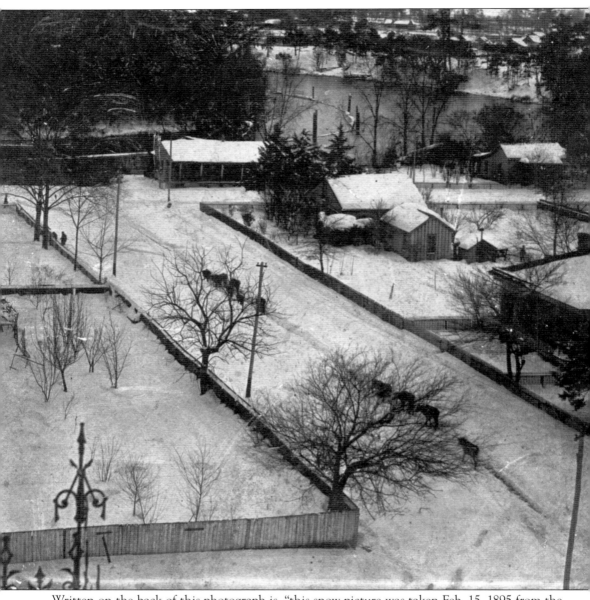

Written on the back of this photograph is, "this snow picture was taken Feb. 15, 1895 from the top of the courthouse looking down Pearl Street toward the Neches River. Snow was 28 inches deep on the ground and almost covered the fence in drifts." Livestock can be seen walking or being driven down the middle of the street, and a few people have come out to brave the unusually cold weather. (Courtesy of Tyrrell Historical Library.)

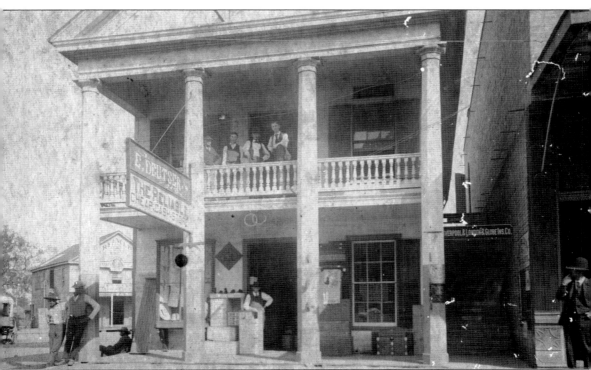

E. Deutser's Store was located at Crockett and Main Streets. The building is a two-story, Greek Revival structure with four columns. Hanging from the left pair of columns is a sign that reads, "E. Deutser, The Reliable Cheap Cash Store." Leaning on the far left column are a man and a boy. Behind them, another man sits on the ground against the building. Farther left is a horse-drawn wagon heading toward distant buildings and a tree. At center in front of the doorway, a man with a hat stands next to boxes with shoes on top. On the second-floor porch are four men, and on the right is another building. Between the two structures is a staircase with a sign that reads "Liverpool & London & Globe Ins. Co." A man in a hat and a suit stands in front of the far-right building. The back of photograph reads, "Deutser Old Store, Crockett & Main St. 202.16 Crockett. Deutser, B—furniture Co., Furniture Dealers. Bernard Deutser, Pres & Treasurer. E. Deutser. 1895." (Courtesy of Tyrrell Historical Library.)

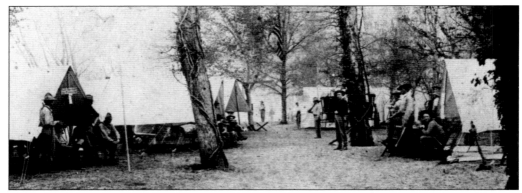

Spanish-American War soldiers camp with tents set up on each side of this 1898 photograph. Cots and tables can be seen inside the tents. Several of the men hold rifles, and a man on the far right has a bugle at his side. Two carriages are in the right central area, and an American flag hangs at center. (Courtesy of Tyrrell Historical Library.)

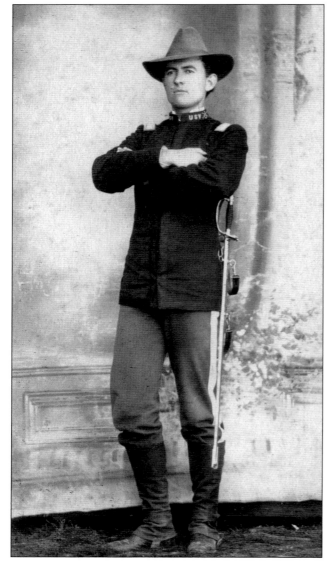

Chenault O'Brien appears in the military uniform of the Beaumont Light Guard in this 1898 image. When the Spanish-American War broke out, the unit drilled locally prior to May 1, 1898, after which it was mustered into service at Camp Mabry in Austin with Chenault O'Brien as captain. The war ended before the unit saw combat. (Courtesy of Tyrrell Historical Library.)

Three

1900 TO 1909

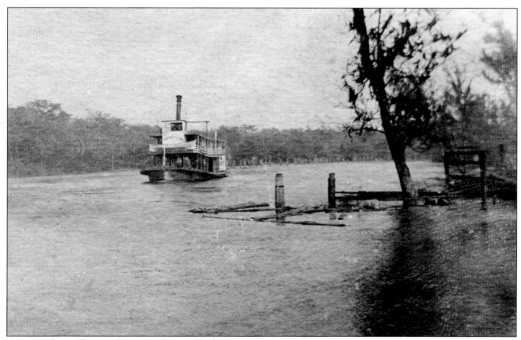

A steamboat floats along a rain-swelled Neches River, illustrating the importance of the river to commercial and recreational interests from the founding of the town. (Courtesy of Sam Houston Regional Library, Liberty, Texas.)

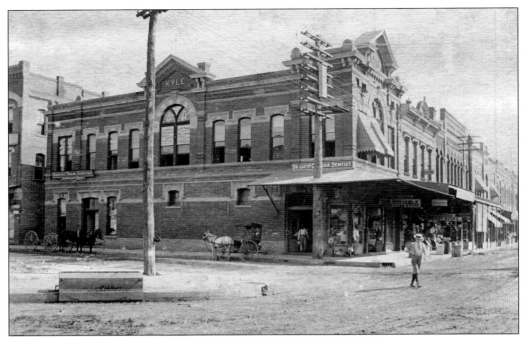

This scene of downtown Beaumont around 1900, complete with the Kyle Theatre Building and dirt streets, shows a young man in the street and men on the sidewalk, as well as businesses such as the Reliable Cheap Cash Store, the Sabine Tram Company (which provided railroad ties, lumber, and mill work goods), and a dentist. (Courtesy of Tyrrell Historical Library.)

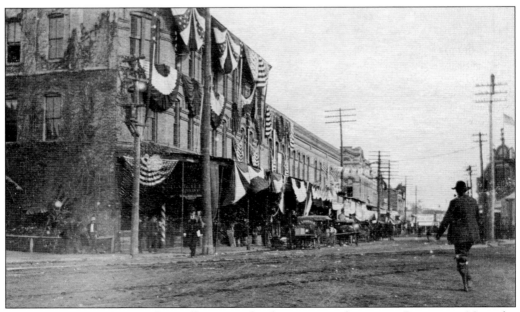

In 1900, a man with a peg leg walks across the dirt street in downtown Beaumont. Note the building decorated in bunting, likely for a Fourth of July celebration. (Courtesy of Tyrrell Historical Library.)

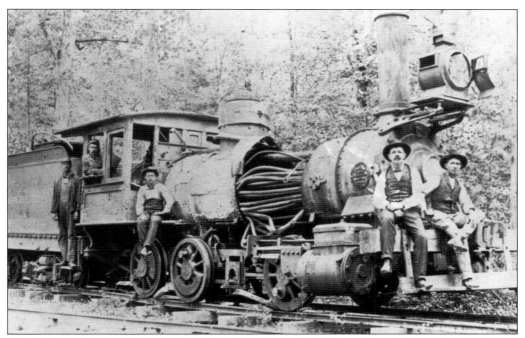

The boiler and steam pipes of this railroad engine in the Kirby Lumber Co. are shown after an explosion in the 1900s. Small trains were used to haul logs for the largest industry in the area prior to the discovery of oil. (Courtesy of Tyrrell Historical Library.)

This woman at a train station garners some attention. Pictured are two fashionably dressed women: one holding an umbrella and another in a hat with a veil. The man on the right is dressed in a suit with a stiff white collar and a hat, and the other man, a conductor, seems quite interested. In the days when trains were powered by coal and the windows were kept open for ventilation, coal cinders flew in the windows and spoiled everyone's clothes and belongings. Black coal dust was everywhere. Red-hot coal cinders also burned passengers' clothes and skin, as well as set fire to things inside the coaches and out in the countryside. This woman is dressed stylishly and for protection. (Courtesy of Tyrrell Historical Library.)

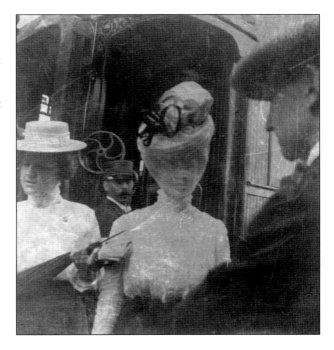

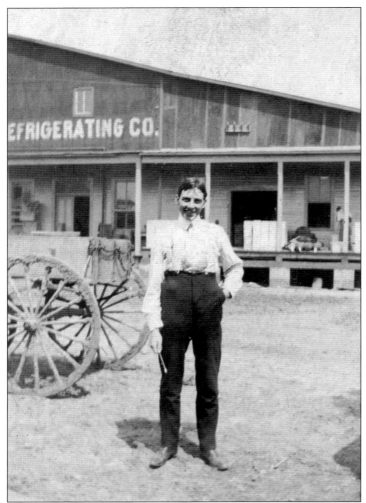

Robert Horton is seen in August 2, 1900, at the Beaumont Ice, Light, and Refrigerating Company plant. (Courtesy of Tyrrell Historical Library.)

The Texas Tram Shipyard had a tram railway to transport materials; in this case, supplies are being loaded for boat construction. The Kansas City Southern Railway trestle bridge across the Neches River is in the background. (Courtesy of Tyrrell Historical Library.)

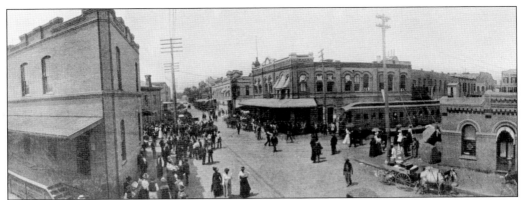

On Pearl Street, near the crossing of the Southern Pacific Railway, Fulton's cafe in the Ogden Building is just beyond the train car. The small building on the right with arched windows is a Wells Fargo bank. The caption on the front of the picture reads, "Scene in Beaumont During the Oil Boom," but the caption on the back says this is a photograph from the Higgins Standard Oil Co. Prospectus, 1901 Smythe Shepherd collection. Another similar photograph says the building with the arched windows is the Wells Fargo building and the Ogden Building is in the foreground, situated on Pearl Street at the Southern Pacific Railway tracks. The railroad car is said to be the private car of John Warne "Bet a Million" Gates, who had major holdings in railroads, oil, pipeline, refineries, and the establishment of Port Arthur, but got his start in a new invention called barbed wire. The building on the left is either the freight office or the depot of Southern Pacific. There are no trolley wires or tracks on Pearl Street, so this is likely prior to 1900. (Courtesy of Tyrrell Historical Library.)

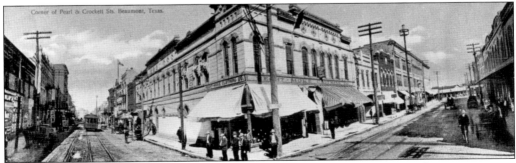

This panoramic postcard of the corner of Pearl and Crocket Streets looks north. A notation on the back says the streetcar is drawn by horse. There are no overhead electrical lines for the (later, electric) streetcars, so this is believable, even though the horse is not seen. (Courtesy of Tyrrell Historical Library.)

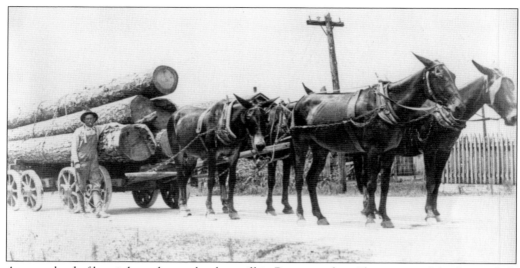

A wagonload of logs is brought to a lumber mill in Beaumont by a "four-up team" (or four mules). At the time, logs, lumber, machinery, or any heavy load was moved by mule-power in the oil, lumber, and every other industry. (Courtesy of Tyrrell Historical Library.)

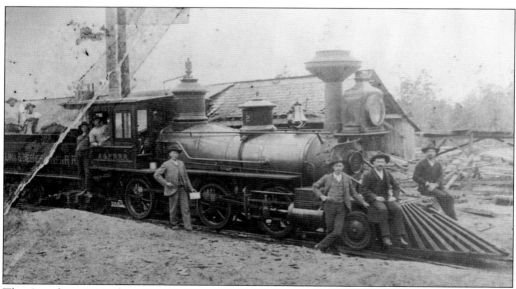

The Angelina & Neches River Railroad (A&NR) Engine No. 2 was the first locomotive for the A&NR, which was a narrow gauge railroad from 1900 to 1906. While the people are not identified, the caption reads, "They are possibly 'Sunday Engineers' due to their dress and lack of work activity." The Angelina & Neches River Railroad was the common carrier/logging railroad of the Angelina County Lumber Company with sawmills at Keltys, Texas, now part of Lufkin. The A&NR still operates as a standard gauge railroad today. (Courtesy of Tyrrell Historical Library.)

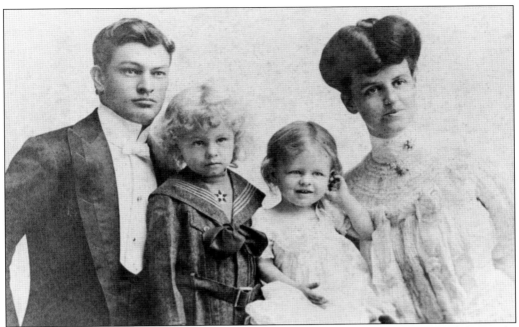

The Kyle family, pictured in about 1900, was prominent in many areas of life. From left to right are Wesley W. Kyle, sons Wesley Jr. and Brudge, and wife Clyde (Wiess) Kyle. Wesley built the Kyle Opera House, which marked the end of Orleans Street at Liberty Avenue; it was torn down in 1931. He was involved in many of Beaumont's social, civic, and business matters, including the McFaddin, Wiess-Kyle Rice Milling Company, and other business enterprises. (Courtesy of Tyrrell Historical Library.)

Alabama Eglantine Keith married Archibald N. "A.N." Vaughan on January 1, 1868, when Vaughn served as tax assessor-collector of Jefferson County. They had four children: Nicholas, Florence, Anna, and Addie. In 1858, Vaughn established the Beaumont Male and Female Academy, offering geography, higher math, painting, and the basic subjects of reading, writing, and arithmetic. In 1860, he founded, wrote, and published the *Beaumont Banner*, the town's first newspaper, which he continued until the beginning of the Civil War in 1861. He also served as mayor of Beaumont from about 1860 to the start of the war, during which he served in Hood's Brigade. After the war, he moved to Cairo, Texas, to manage the Texas Tram and Lumber Company's commissary. He died there in 1883. Alabama never remarried, and died in 1910 in Beaumont. (Courtesy of Tyrrell Historical Library.)

Florence Stratton, the valedictorian of her graduating class at Troy State Normal College in Alabama in 1900, was born to Judge Asa Stratton and Emily Bryan Stratton and moved with her family to Alabama, where she graduated from high school and college before returning to Beaumont. In 1920, she began working for the *Beaumont Enterprise*, where she became the society, food, and garden editor. Later, she wrote *The Story of Beaumont*, the first history of Beaumont. (Courtesy of Tyrrell Historical Library.)

Capt. Anthony Lucas, the geologic engineer who drilled the Spindletop gusher, changed the world by making modern transportation possible. (Courtesy of Tyrrell Historical Library.)

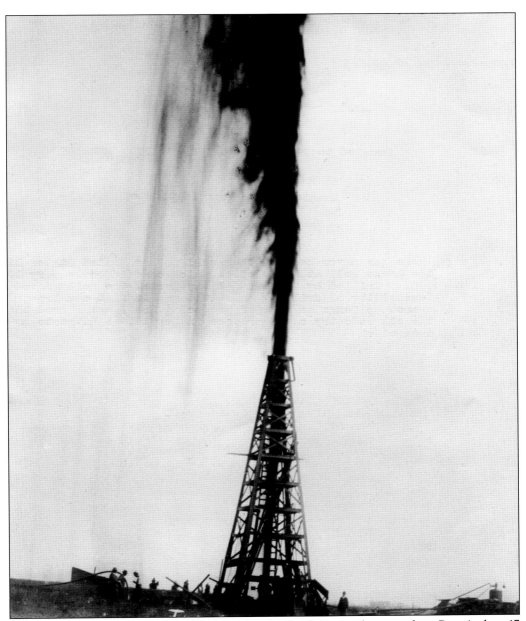

This picture of the Spindletop gusher was taken by Frank Trost, who came from Port Arthur, 17 miles away, with his photographic equipment after he received word of the gusher. At the bottom of the derrick on the left, workers can be seen, and on the right is the lone figure of Capt. Anthony Lucas. Men on horseback who came to see the well are visible behind the workers on the left. As the historical marker at the site notes, "With his unwieldy camera equipment in tow, [Trost] managed to take at least one photograph of the gushing oil before sundown. Photographic methods were still in their infancy, so the image was created with a glass negative Trost manufactured in his studio. The photo appeared in newspapers all over the United States and in some foreign countries. It was in such demand that Trost made as many as 250 prints per day and sold them as quickly as they were printed." (Courtesy of Tyrrell Historical Library.)

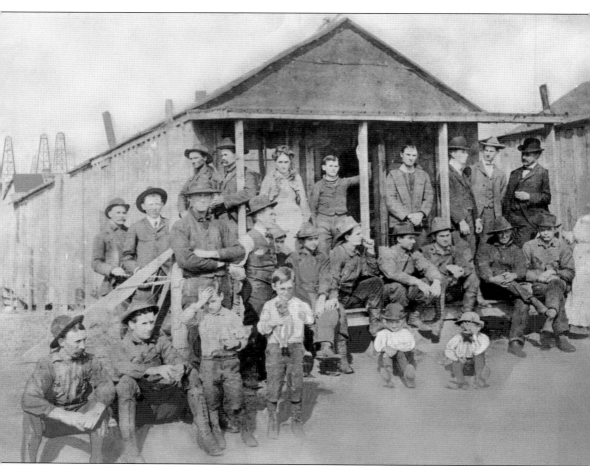

This is Lillian Elizabeth Keenan's boardinghouse at Gladys City, also known as Spindletop Hill, just south of downtown Beaumont. The photograph shows Keenan (third row, third from the left) among a group of boarders, made up of 20 men, a few boys, and another woman on the right. In the background are other buildings and oil derricks at Spindletop. In the first row, third and fourth from left, are Charles and James Keenan, respectively. The building is narrow and long, and oil derricks can be seen in the background on the left. (Courtesy of Tyrrell Historical Library.)

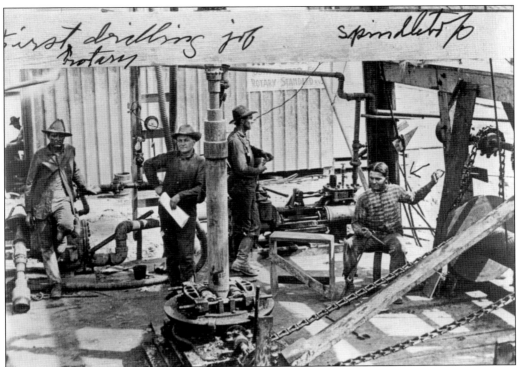

While this is not a photograph of the drilling crew of the Spindletop gusher, drilled by the Hamil brothers, it is a famous photograph of the "first rotary drilling job [at] Spindletop" for a crew. The equipment used on the drilling rig is modern and more advanced than that used by the Hamil brothers on the original Lucas gusher. (Courtesy of Tyrrell Historical Library.)

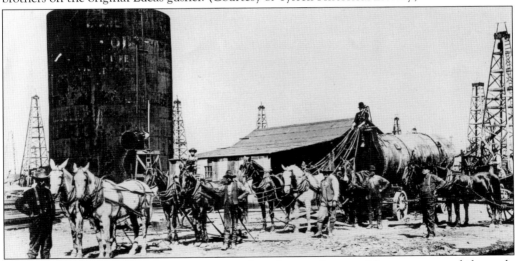

Spindletop oil field transportation was carried out by a mule team. Here, men attend the mule team and wagon. Four teams were used to move a boiler on a Sun Oil lease. The men are, from left to right, Charles Radka, Jim Myers, Bill Hill, and driver Al Castom. An early wooden storage tank stands behind the mules, and a building and derricks in the oil field can be seen. (Courtesy of Tyrrell Historical Library.)

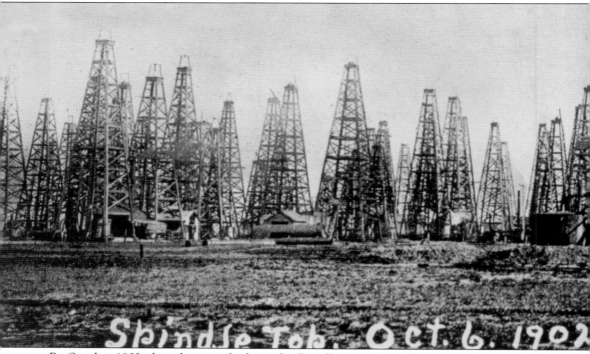

By October 1902, derricks were thick on the Spindletop prairie. The saying, "You could walk across the whole Spindletop oil field without touching the ground" was obviously true. Platforms were built so closely together that walking from one to the other was possible. There were some

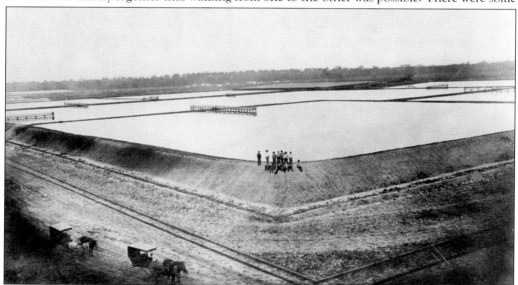

According to the writing on the back of this image, "No one was prepared for the bountiful supply of oil that gushed from the earth. At Spindletop, where everything was done in a big way, this earthen storage excavation [held] no less than 3,000,000 barrels of oil. As a result of improved methods of controlling well output, these spectacular but dangerous and wasteful 'lakes of oil' have . . . disappeared from the oil landscape." (Courtesy of Tyrrell Historical Library.)

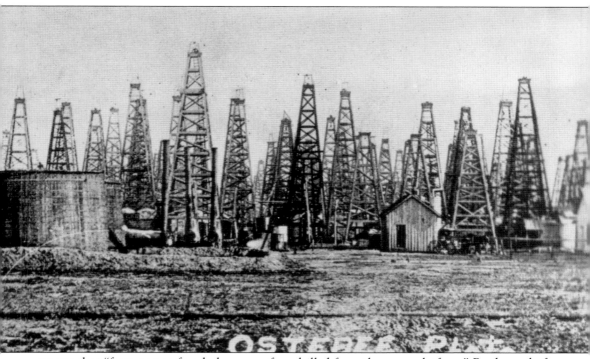

reports that "from one to four holes were often drilled from the same platform." By the end of 1901, approximately 585 oil and leasing companies were doing business in Beaumont, and there were about 138 producing wells on the Spindletop Hill. (Courtesy of Tyrrell Historical Library.)

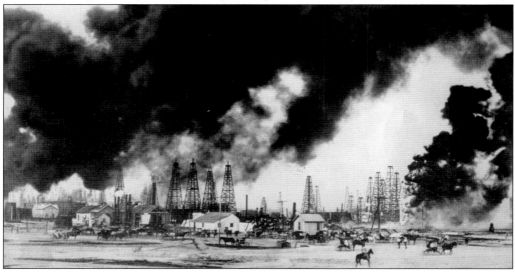

This oil fire at Spindletop illustrates that fire was a constant danger, especially in the early days when oil was pumped into open sumps that held more than a million barrels of oil exposed to any match or spark. The first fire was at the original Spindletop well and was caused by a careless cigarette. The next took place at a million-barrel open lake and was sparked by live cinders from a coal-powered train. With the supply of oil coming from Spindletop, trains soon switched to oil power. (Courtesy of Tyrrell Historical Library.)

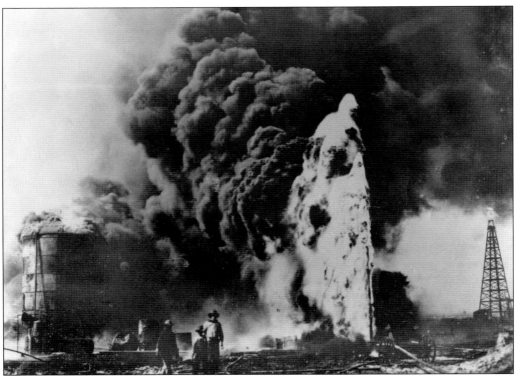

Here is another view of a dangerous oil field fire threatening men and equipment. The danger to working men and all the surrounding area is obvious. (Courtesy of Tyrrell Historical Library.)

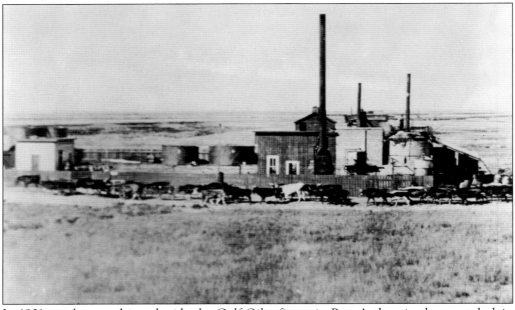

In 1901, cattle were driven beside the Gulf Oil refinery in Port Arthur, in the coastal plain pasture that might have been used for farming or feeding cattle prior to the oil boom. (Courtesy of Tyrrell Historical Library.)

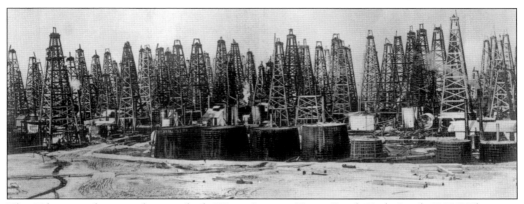

This Edgerton photograph is marked, "Hogg-Swayne Tract, South End, April, 1903." The tract was owned by former governor James S. Hogg of Texas and his partner James W. Swayne and was one of the most productive in the Spindletop field. J.S. Cullinan later incorporated it into his Texas Fuel Company properties, which became the Texas Company, or Texaco. (Courtesy of Tyrrell Historical Library.)

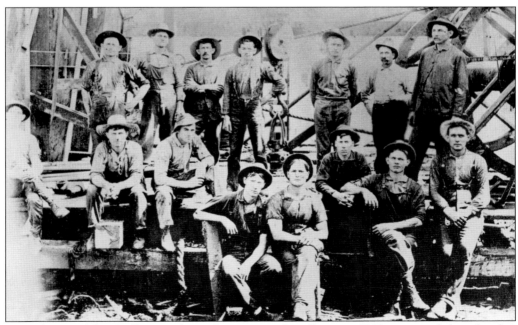

Roustabouts of the Guffey Petroleum Company at Spindletop in 1903 supported their families by the oil boom. (Courtesy of Tyrrell Historical Library.)

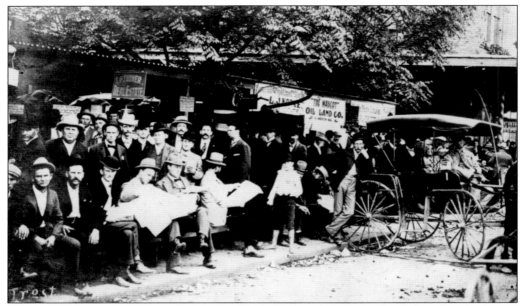

Boomers congregate in front of the Crosby House hotel. Men (and one barefoot boy) read newspapers, apparently ready to discuss the deals that could be made for land with possible producing wells. Signs in the background advertise real estate, the Texas Oil Pipeline Company, and others things. Men sit in the carriage, and at least one finely dressed woman stands on the other side of the carriage. (Courtesy of Tyrrell Historical Library.)

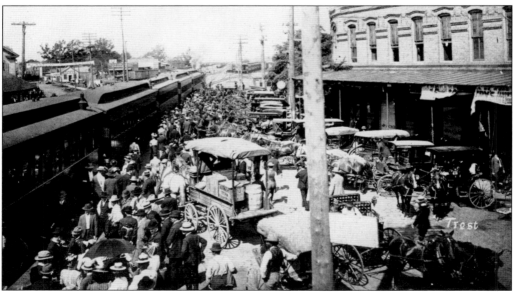

The Southern Pacific train station saw multitudes of people coming and going during boom times. (Courtesy of Tyrrell Historical Library.)

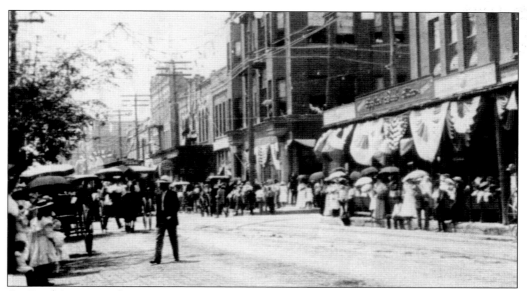

On Pearl Street at Liberty Avenue, with the Wiess Building at center, people and properties are dressed for the Easter parade. Horse-drawn carriages, a streetcar, and a bicycle are present in this view looking south. (Courtesy of Tyrrell Historical Library.)

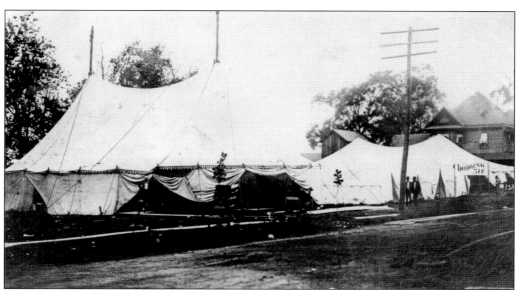

Lodging was still at a premium in 1902, and these sleeping tents and lodging house show the often-muddy Beaumont streets with board sidewalks in place. After Spindletop, Beaumont went from a farming town of 5,000 to over 50,000 almost overnight with no place to put all the new people, so along with the usual hotel rooms, spare rooms were rented in homes, and cots in stores, pallets on floors, barber chairs, porches, and even tabletops in bars were set up for those looking for a place to rest. (Courtesy of Tyrrell Historical Library.)

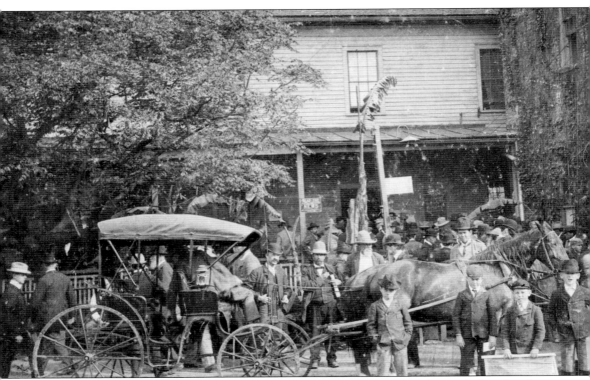

This view of the excitement of daily life in boomtown Beaumont in front of a hotel and store shows men, boys, and a horse-drawn carriage. Signs say, "Read the News," (offering Galveston and Dallas newspapers) and "Postal Telegraph Office." A realty company blackboard hangs on the wall. (Courtesy of Tyrrell Historical Library.)

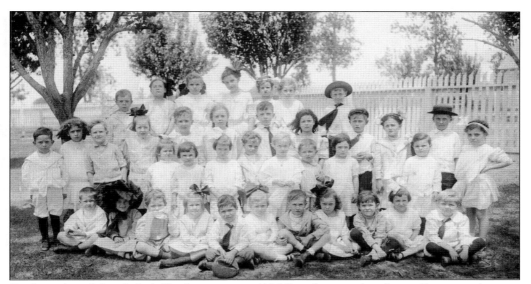

Students from Miss Cahn's Kindergarten, at 1196 Broadway, gather for an Easter egg hunt at Broadway and Center Street. Seated in the first row are, from left to right, ? Weed, Anna Marie DuPerier, Edward Omahundro, Mary Weed (future wife of Jack Fletcher), Alfred DuPerier, Maydee Pedigo (future wife of Jack McDonough), Adriance Bordages, Hester Perl (future wife of ? Greenberg), two unidentified children, and Donald Davis. (Courtesy of Tyrrell Historical Library.)

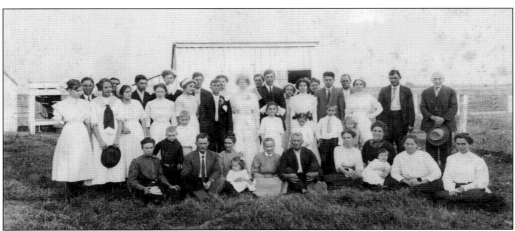

The wedding party of Ed Hebert and his wife, Grace Fae Dutton Hebert, are pictured outside the family home. Ed was the son of J. Martin Hebert and Effie Hebert. The happy couple is in the middle of the image, taken on the farm where the wedding took place. Viewed close-up, each person is an interesting study. (Courtesy of Tyrrell Historical Library.)

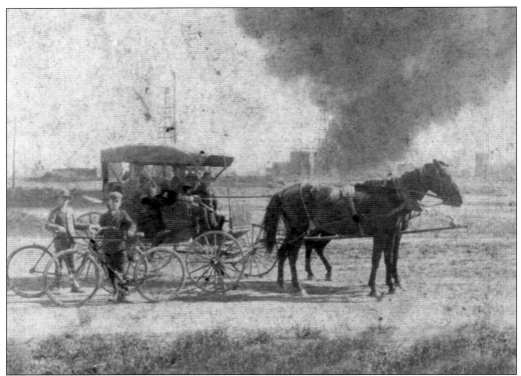

"Uncle" Jim Weller drives his surrey, drawn by two horses, to observe an oil field fire. Two boys stand beside it, holding their bicycles. In the surrey are five people: one dressed-up lady in the back and perhaps three people and a child in and around the front seat. (Courtesy of Tyrrell Historical Library.)

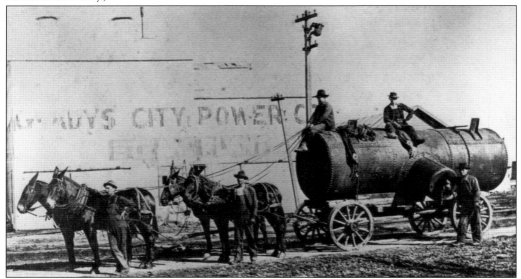

A riveted steel tank is being driven past the Gladys City Power Company steam plant on a horse-drawn wagon. A man drives the mules, one rides the tank, and one stands beside the wagon and tank. One man stands beside each team of mules as well. (Courtesy of Tyrrell Historical Library.)

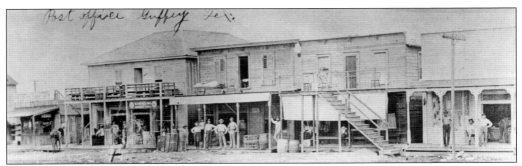

Gladys City was also known as Guffey, Texas. In this picture of a row of buildings, some of the second-floor rooms are sleeping quarters for workmen, featuring a makeshift bed on an open porch. (Courtesy of Tyrrell Historical Library.)

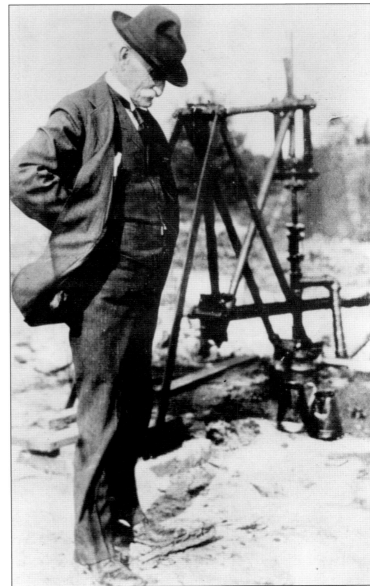

John H. Galey ponders work at Spindletop. Galey and James Guffey were respected drilling contractors who worked with Captain Lucas to drill the well at Spindletop. They hired the Hamil brothers to do the drilling. (Courtesy of Tyrrell Historical Library.)

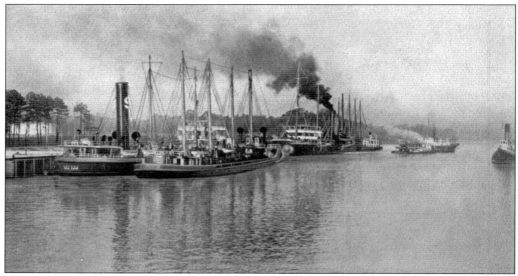

Steam tankers at the Magnolia Refining Company docks wait to be loaded in 1905. The "S" on the tanker at the docks stands for "Socony." The Socony-Vacuum Oil Company, split off from Standard Oil, bought the Magnolia Petroleum Company, which became Mobil and then Exxon-Mobil. (Courtesy of Tyrrell Historical Library.)

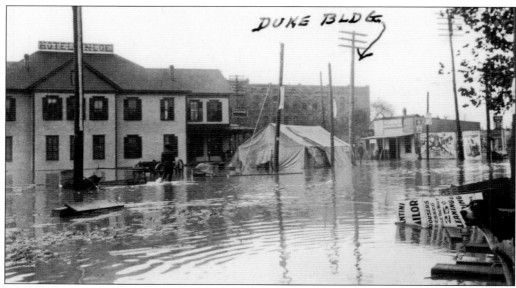

This flooded street is identified on the bottom of this 1902 photograph as Orleans Street near the corner of Liberty Avenue. The Hotel Enloe is identified by a sign over the first building on the left. The Duke Building is also identified in writing on the photograph. One man walks through the water, and another is seen to the right of the tent. Also, a not-happy dog in the right corner. The toppled sign on the right is from Martini Tailors, who would press trousers for 25¢ "while you wait" and also offered "cleaning and ironing." (Courtesy of Tyrrell Historical Library.)

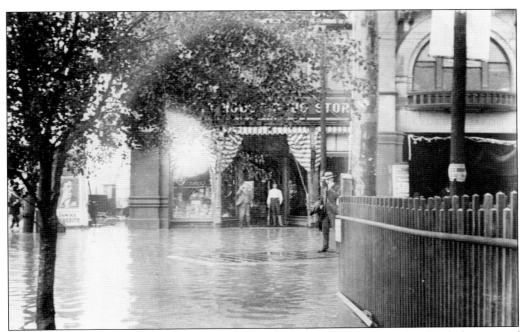

The Thomas Drug Store is seen in this November 1902 photograph at the flooded corner of Orleans Street and Liberty Avenue. The Kyle Theatre Building is to the right, and the picket fence is in front of the Goodhue home. (Courtesy of Tyrrell Historical Library.)

When the terrible Galveston Storm swept the island with 15 feet of seawater and 140 mile-per-hour winds, causing the deaths of 8,000 to 12,000 people, the largest disaster in US history, Beaumont sent aid in the form of ice, food, building material, and medical supplies and laborers. The Beaumont Ice, Light, and Refrigerating Company supplied the ice. The devastated island was completely rebuilt with private funds, including raising the island 15 feet behind a newly constructed 17-foot seawall. (Courtesy of Tyrrell Historical Library.)

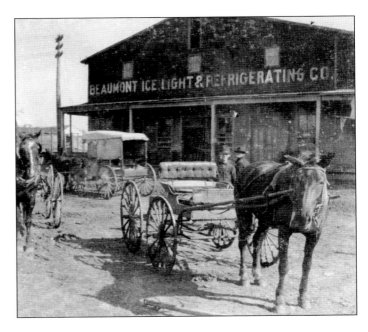

Herford's Oyster House, located on the banks of the Neches River, is seen from the foot of Pearl Street South, looking toward the site of former hospital Hotel Dieu. The frontier nature of the scene shows bushes and trees, with very little evidence of improvements to the area. (Courtesy of Tyrrell Historical Library.)

In this south-facing view of Forsythe and Main Streets, a gentleman in business attire leans on a fence post as his dog runs along the dirt road. Buggy tracks, tents, sheds, and houses illustrate the quality of life at the time. (Courtesy of Tyrrell Historical Library.)

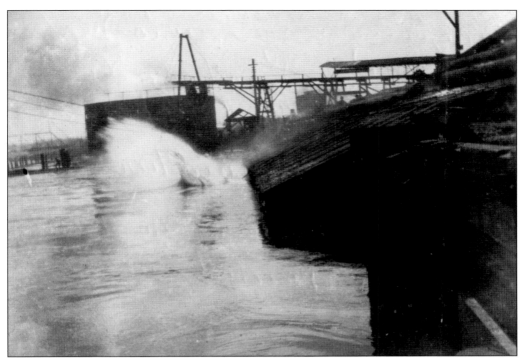

Logs are being dumped into the Neches River near the foot of Hickory Street. In the background are a slab burner of the Texas Tram and Lumber Company and the Kansas City Southern Bridge. (Courtesy of Tyrrell Historical Library.)

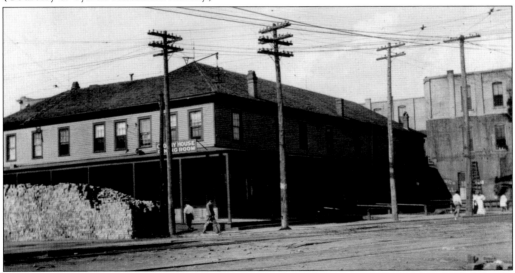

Beaumont became a primary railroad stop between New Orleans and the West Coast. The Crosby House Hotel and dining room was named for the president of the Texas & New Orleans Railroad, J.T. Crosby, located opposite the Texas & New Orleans depot. In this 1906 photograph, men and women walk past the building and its many improvements, including more electrical and telephone lines and overhead electrical connections for streetcars. The stack of bricks may have been for the construction of a building or future street paving. (Courtesy of Tyrrell Historical Library.)

Alba Heywood, a noted entertainer turned oil speculator and entrepreneur, wrote about his second well, Heywood No. 2: "Height of oil flow: 217.3 feet; Capacity: 70,000 barrels per day; brought in on May 25, 1901. You talk about Old Faithful in the National Park out west / Why he just spouts a little while, then an hour of rest / But Heywood No. 2, by jing! He spouts all day and night / He never stops to breathe or rest or appease his appetite / He doesn't grumble, growl and roar and hiss and seethe and boil / He doesn't spout "aqua pura" but a steady stream of oil!" This photograph is of the Heywood No. 3 well. (Courtesy of Tyrrell Historical Library.)

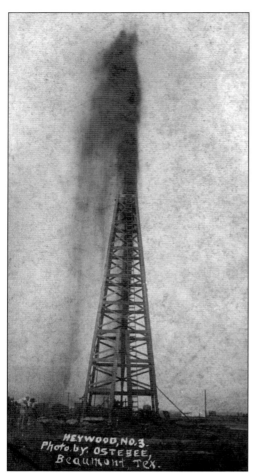

HEYWOOD, NO. 3.
Photo. by. OSTEBEE,
Beaumont Tex.

According to *The Standard Blue Book of Beaumont, 1903*, "The French Market Grocery Company in the Alexander Building is easily one of the most complete and handsome places of its kind in the South. Hundreds of people visit the store merely to look at it . . . and thousands visit it to purchase the excellent articles always on sale." Proprietors say Anthony Lucas was shopping here when the gusher bearing his name came in. (Courtesy of Tyrrell Historical Library.)

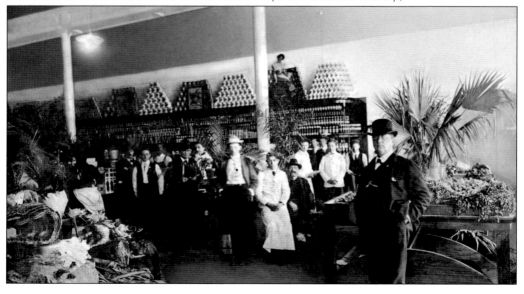

The family of Hymen Harris, born in Germany, and his wife, Fannie, born in Poland, came to Beaumont to make a new life for themselves and their children—Rafael and Isadore—both born in Beaumont. The family opened the H. Harris Furniture Company. (Courtesy of Tyrrell Historical Library.)

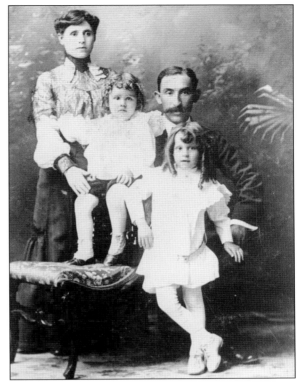

Mrs. W.A. Nichols and a young Rugh Chambers walk from the porch to the front fence on the 900 block of North Street in 1903. Note the horse in the background. (Courtesy of Tyrrell Historical Library.)

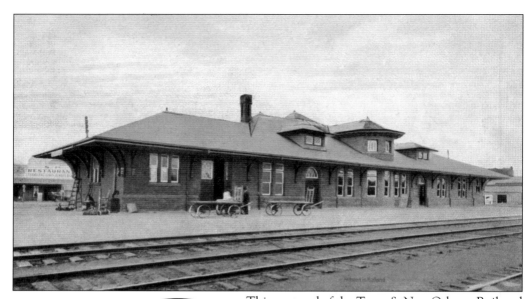

This postcard of the Texas & New Orleans Railroad station at 900 Laurel Avenue has a printed inscription on the back reading, "The T. & N. O. Station.—The Sunset Depot—was built by the Texas and New Orleans Railway and was completed in 1904. In the centre of the rapidly growing city, it parallels its principal street. There are equal accommodations for negroes and whites, their quarters being separated by the ticket office." It became the Southern Pacific station. (Courtesy of Tyrrell Historical Library.)

Vallie Fletcher, daughter of "Rebel Private" W.A. Fletcher, a prominent Beaumont lumberman, became a noted painter in her own right with many commissions, although she gave many of her paintings away to friends and family. (Courtesy of Tyrrell Historical Library.)

Col. James M. Guffey, for whom Guffey, Texas, was named, is pictured here. He, along with Galey and Lucas, brought in the Lucas gusher. Guffey was an oilman from the Pittsburgh, Pennsylvania, area who invested in the original attempts to bring in oil in Texas. (Courtesy of Tyrrell Historical Library.)

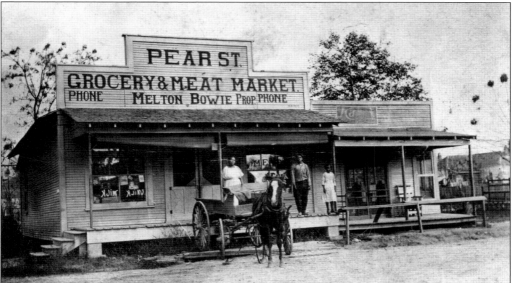

Pear Grocery Store, a grocery and meat market located on Pear Street, had a wood building with a porch and a false front. At center is a horse-drawn wagon with boards underneath, offering a smooth loading place. Standing on the porch behind the wagon is a woman, and to the right of her are a young man and a girl. There is another wood building with a porch adjoining the grocery store. Melton Bowie was the owner of the family-run Pear Street Grocery, as well as a local carpenter. He was one of Beaumont's first black businessmen. (Courtesy of Tyrrell Historical Library.)

A horse-drawn carriage, participating in a parade, is decorated with flowers and carries ladies with lace umbrellas. (Courtesy of Tyrrell Historical Library.)

Capt. George O'Brien came from Louisiana to the Beaumont area in 1849 and became a businessman, county office holder, lawyer, and an early investor in oil speculation. He successfully backed the efforts of Pattillo Higgins, George W. Carroll, J. F. Lanier, and Anthony Lucas in bringing in the Spindletop oil field. (Courtesy of Tyrrell Historical Library.)

Manie Blewett was a member with four other young ladies of the singing group Belles of Beaumont in 1906. (Courtesy of Tyrrell Historical Library.)

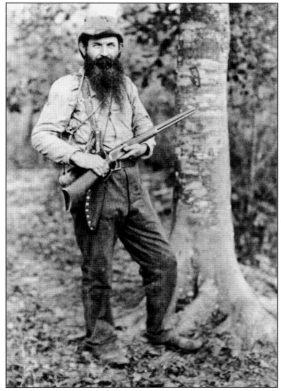

Famous hunter Ben Lily, who guided hunting expeditions with Pres. Theodore Roosevelt and many others, is pictured on the Big Thicket Bear Hunt in 1906. J. Frank Doby wrote a book about him. (Courtesy of Tyrrell Historical Library.)

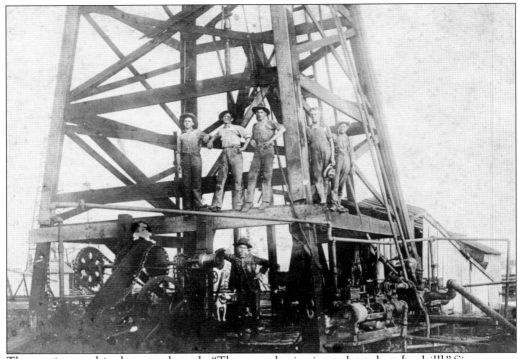

The caption on this photograph reads, "They were beginning to learn how [to drill]." Six men are pictured on a Spindletop oil field derrick in 1906. (Courtesy of Tyrrell Historical Library.)

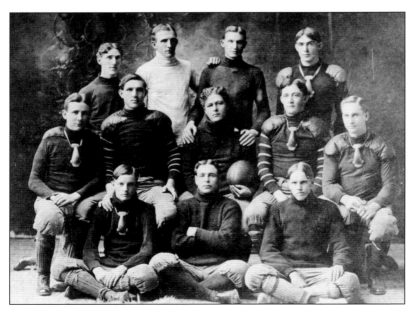

Pictured here is an early local football team. The only men identified are Hubert Oxford (second row, far left) and William Shepherd (first row, far right). (Courtesy of Tyrrell Historical Library.)

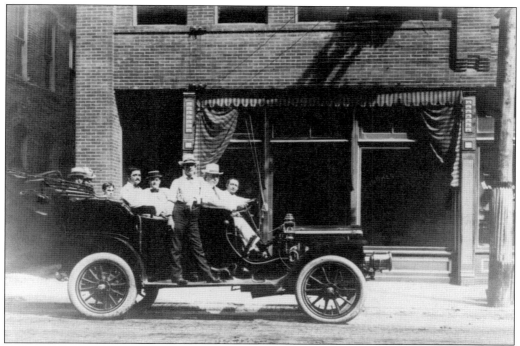

The auto passengers in 1907 on Bowie Street next to the Gilbert Building include J.S. Edwards (sitting in the rear at left), who was involved in insurance and real estate. This photograph was donated by Lum C. Edwards Jr. and Martin Edwards. (Courtesy of Tyrrell Historical Library.)

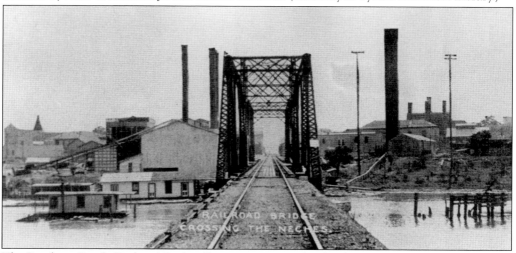

The Southern Pacific Railroad Bridge illustrates an example of early Beaumont rail transportation. When Henry Millard laid out the town, he reserved several mill sites on the river. This image shows several mills operating in the part of town that was reserved for the industry. On the left is a church steeple thought to be that of First Baptist. Buildings of downtown Beaumont can be seen in the background, and to the left is a lumberyard. The bridge was no longer needed by the Southern Pacific Railroad after its consolidation with Missouri Pacific Lines. Because it caused navigational problems for large ships entering or leaving the port, it was removed on December 27, 1969. (Courtesy of Tyrrell Historical Library.)

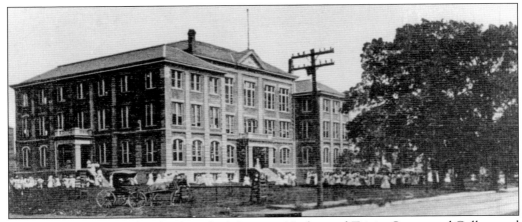

The first Beaumont High School was built between Neches and Trinity Streets and College and Wall Streets on a block of ground shown on the Rachford's Map of the city of Beaumont in 1897 as College Square. This tract was donated by Nancy Tevis and Joseph Grigsby for school purposes only. Even after this building was demolished, the school maintained its administration offices in an auxiliary building. This picture was taken for a very special event since there are only ladies present and all of them are dressed in long, white dresses. (Courtesy of Tyrrell Historical Library.)

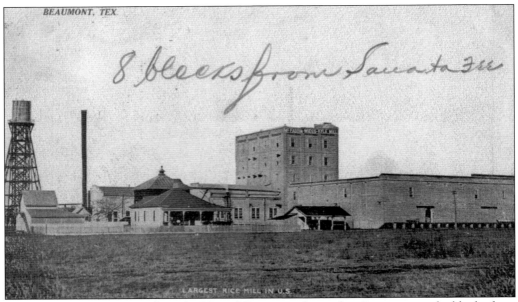

In 1908, the largest rice mill in the United States was located in Beaumont eight blocks from the Santa Fe railroad station. A handwritten note on the back of this postcard reads, "8/26/08, was home yesterday. Everything all ok. Glad you are having a nice time and all ok now will go back some time this eve working all the time, Lovingly, Bert," and was addressed to Mrs. Bert Hollandsworth, Alvin, Texas. (Courtesy of Tyrrell Historical Library.)

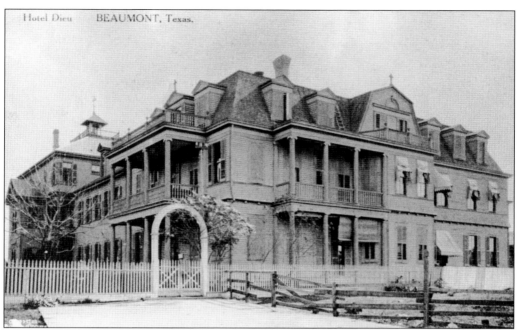

Hotel Dieu BEAUMONT, Texas.

The original wooden structure of Hotel Dieu hospital in 1908 was later replaced by a large dark redbrick building but was always located near the turning basin of the Port of Beaumont. (Courtesy of Tyrrell Historical Library.)

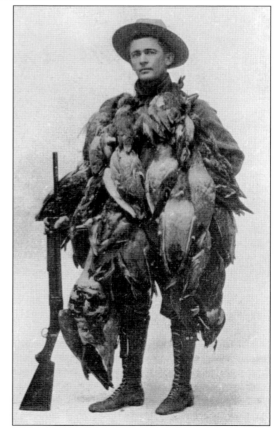

J.M. Beatty, of the prominent Beatty family that had brought in the second well at Spindletop, went out for a morning hunt and came back with what was described as "a fair bag of ducks and geese" when game was plentiful around the turn of the 20th century. (Courtesy of Tyrrell Historical Library.)

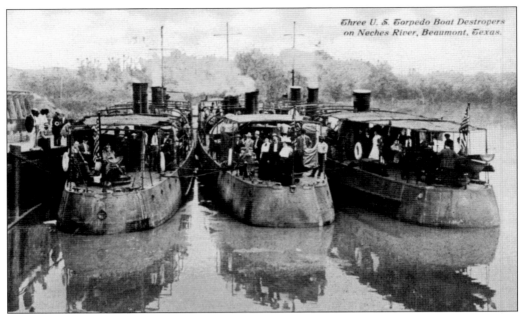

Three torpedo destroyers visited Beaumont in 1909. A newspaper report said that it was the first time that US warships had ever visited the area, and officials claimed it as recognition of Beaumont as a significant deepwater port. Half of the town's population of 20,000 were said to be at the water to view and tour the vessels, and the event was the most exciting since the drilling of the Spindletop gusher. (Courtesy of Tyrrell Historical Library.)

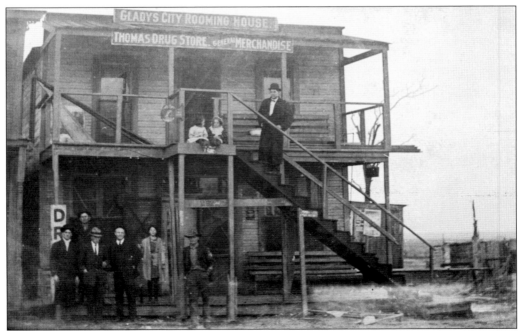

The Gladys City Rooming House and Thomas Drug Store provided for many needs in the Spindletop boom days. (Courtesy Texas Energy Museum.)

Four

1910 TO 1919

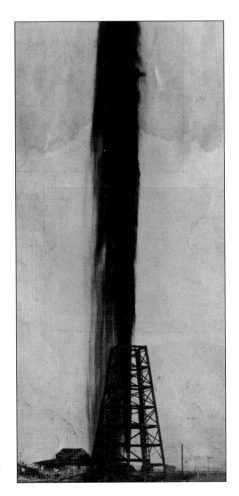

The Spindletop boom did not stop with one well, as more developments were coming. Pictured here is Heywood gusher No. 2. Its height of oil flow was 217.3 feet, and its capacity was 70,000 barrels per day. (Courtesy of Tyrrell Historical Library.)

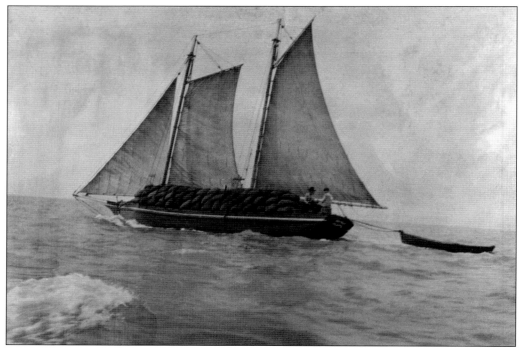

Agriculture remained integral to Beaumont's economy, as seen in this picture of a "Schooner on Galveston bay 20 miles from port taken from private boat," as written on the back. A caption on the front reads, "Sail Packet Boat out of Beaumont with a cargo of rice." (Courtesy of Tyrrell Historical Library.)

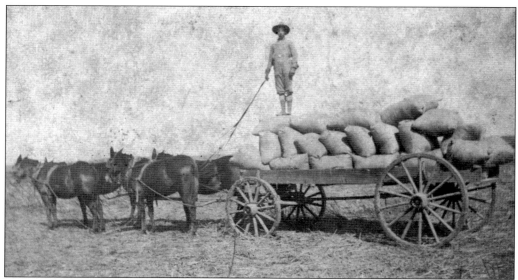

A wagonload of rice at harvest time is pulled by two teams of mules. A driver stands atop the bags of rice with the reins for the mules in his hand. (Courtesy of Tyrrell Historical Library.)

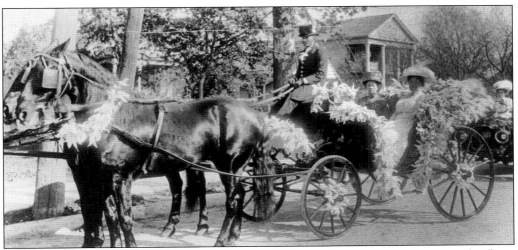

Carriages, like this one decorated for the Fourth of July parade, were the precursors to the floats seen in parades today. Wilkens Green is the driver, and Mary Gilbert Fuller (left) and Laura Wilbarger Gilbert ride in the horse-drawn carriage. Aurelioa McCue Norvell drives the car behind the carriage. This picture was taken near the Alexander Calder house, located at 600 Calder Avenue. The carriage, wheels, and even the horse wore flowers. Before modern-day floats, cars or horse-drawn carriages were decorated with flowers and garlands, and ladies, particularly, wore their finest. (Courtesy of Tyrrell Historical Library.)

A.E. Hackebeil, seen here with his horse and buggy, came from Rutersville in Fayette County, Texas, and his horse, buggy, and furniture were shipped by rail to Beaumont in 1912 from LaGrange. Hackebeil's father rode in a boxcar with a horse and cow from LaGrange to Beaumont. A.E. Hackebeil established a monument manufacturing plant at 2005 Grand Avenue in Beaumont around 1914. (Courtesy of Tyrrell Historical Library.)

Donna Hooks Fletcher, said to have the wholesome good looks of a "Gibson Girl," was the daughter of T.J. Hooks of Hidalgo, Texas, who purchased more than 20,000 acres in Hidalgo County in 1900. According to an interesting story from Mike Cox of Texasescapes.com, as she was living in the Rio Grande Valley, the railroads were not yet finished to Brownsville when she received word of a dear relative being ill in Beaumont. Fletcher persuaded the railroad-engineering contractor to let her ride in a freight car from Barredo to Robstown, where she could connect with passenger trains to Corpus Christi on their way to Beaumont. He locked her in a boxcar with a sack of sandwiches and bucket of water, keeping her safe from rough characters who might wish her harm. She arrived the next morning in Robstown and was released by workers. The story of her spirit so impressed the president of the new Brownsville Railroad that he named a town for her—Donna, Texas—where she later came to live and be postmistress. (Courtesy of Tyrrell Historical Library.)

Edward Teel Nolen and his wife, Johnnie Addie Baker, spent most of their life in Tyler County, Texas, but came to Beaumont during the oil boom. One of their children settled in Honey Island, a former lumber town with a large spring-fed pool and recreation area. (Courtesy of Tyrrell Historical Library.)

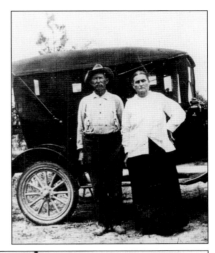

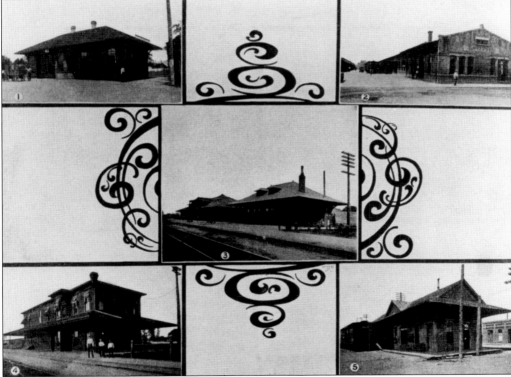

These were the five railroad stations serving Beaumont in the 1910s. At top left is the Kansas City Southern depot for the railroad brought to the Beaumont–Port Arthur area by Arthur Stillwell, a former insurance magnate and large landowner in the Kansas City area; at upper right is the Santa Fe depot for the former Gulf, Colorado & Santa Fe Railway Company, founded by Galveston businessmen to connect with the interior of Texas; at center is the Southern Pacific depot for the larger railroad that had absorbed the Texas & New Orleans Railroad; at lower left is the Santa Fe depot on Calder Avenue; and at lower right is the Gulf and Interstate depot for the line that connected Bolivar peninsula with Galveston via ferry boat and the Beaumont–Port Arthur area. (Courtesy of Tyrrell Historical Library.)

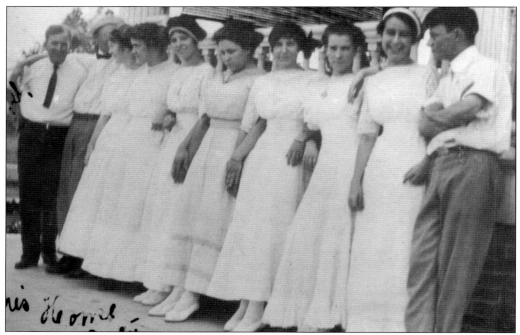

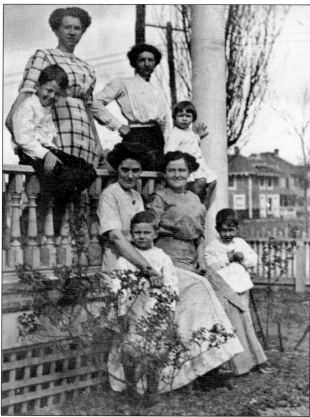

The McFaddin-Ward spring roundup family event was famous for its fun. A group of friends are shown at one of Mamie McFaddin's house parties during "the Titanic Decade," 1910 to 1919. The photograph, taken about 1913, shows Mamie, the third person from the right. The founding family took business seriously but also knew how to have fun. (Courtesy of Tyrrell Historical Library.)

Members of the Emerson and Collier families gather at 2015 Calder Avenue. Pictured are Mrs. Emerson (standing on the porch, left) J.N. Collier (young boy sitting on the rail), Vera Griffin Collier (standing on the porch, right) Virginia Collier (young girl sitting on the rail), Tempe Collier (sitting on edge of porch, left) holding Lon Emerson, Mrs. Fish (sitting on the edge of the porch, right), and Richard Collier (standing at far right). (Courtesy of Tyrrell Historical Library.)

Men survey the Southern Pacific Railroad right-of-way about 1910. The caption on the back reads, "Sometimes it took a little ingenuity. For instance, this survey party needed to stand a little taller to locate the Southern Pacific Rail Road right of way. This was probably in Neches River Bottom." (Courtesy of Tyrrell Historical Library.)

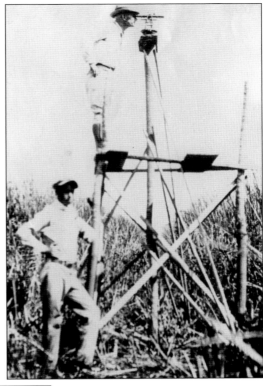

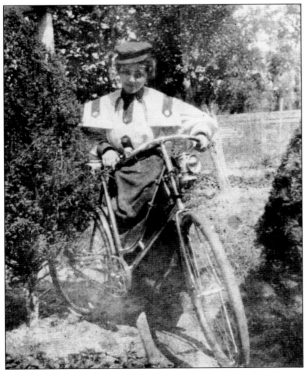

Sybil Orr Duke, stylishly dressed, is pictured here with a fancy bicycle featuring a kerosene lamp on the front. A caption on the photograph reads, "Aunt Sibby French, taken in yard 1898." Sibby was the granddaughter of John J. French Sr. Chicken wire fencing can be seen in the background, as all homes of the time had to supply most of their own food. (Courtesy of Tyrrell Historical Library.)

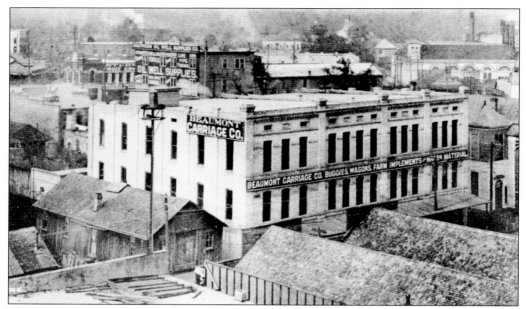

The Beaumont Carriage Company, located on Fannin Street, is the large three-story structure. In the foreground are other wooden buildings and rooftops. In the background is a building adorned with the signs, "Southern Oil Well Supplies, Tools, Line, Pipe, Tubing, Oil Well Supplies," and behind that is the Stedman Fruit Company. (Courtesy of Tyrrell Historical Library.)

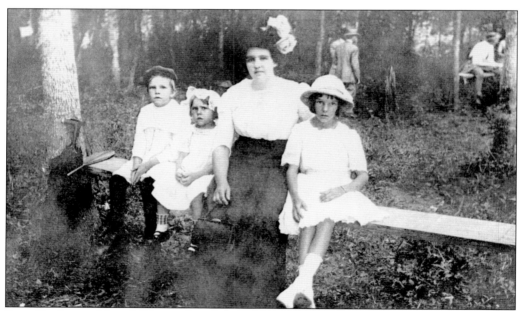

Erna Ostebee and her children—from left to right, Elsie, Edwin, and Lucille—pose on a bench at a picnic in a wooded area. Erna was the wife of Halvor Ostebee, a noted photographer whose work is said to have documented the Spindletop boom and, at the height of his career, the elite of the community. (Courtesy Tyrrell Historical Library.)

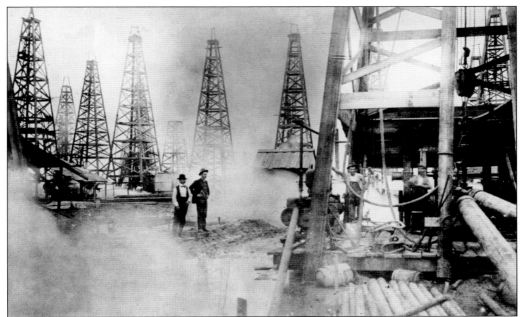

Men work at an oil well at Spindletop oil field surrounded by steam, which was used for powering the drilling rigs. Two men supervise or observe at center, and two workers stand near a pump or drill with other machinery nearby. In the background are several additional wells along with maintenance buildings. Written at the bottom is "#1 Sinking Well," indicating that this was the first well for either this company or this crew. On January 10, 1901, Beaumont's Lucas gusher at Spindletop struck oil and became the first major gusher of the Texas Oil Boom. Gulf Oil, Texaco, and other companies were formed directly to develop production at Spindletop. Texas soon became the world's leading oil producer. This photograph is believed to have been taken around 1910. (Courtesy of Tyrrell Historical Library.)

Dr. Z.T. Fuller's grandchildren, with adult Ruth Chambers in the center, pose near the cistern house of Capt. William Wiess's home, located on the 900 block of Calder Street. (Courtesy Tyrrell Historical Library.)

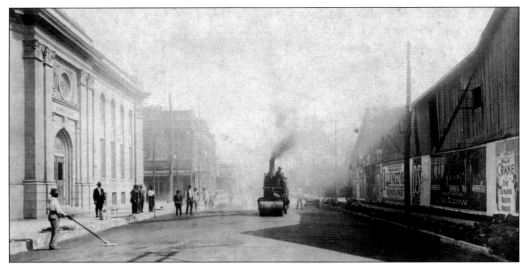

Paving work goes on at the corner of Broadway and Pearl Street in this view looking east on Broadway. The short man standing in the street to left of the steamroller, wearing a hat and dark suit, with his hands in front of his waistband, is possibly James Denny Bordages. He worked for the City of Beaumont and was in charge of a construction crew. Later, he was the foreman for the Broussard-Hebert Cattle Company. A note on this photograph says it was taken in 1913 and that "the work is probably being done with convict labor for the man in the black hat and boots has a star pinned to his coat. The wooden buildings on the right were later torn down and the entire block covered with brick buildings." (Courtesy of Tyrrell Historical Library.)

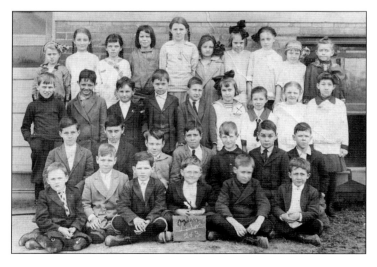

The second and third grade class of Ogden School is pictured here in 1911 or 1912. The handwritten caption reads, "3rd row, 6th from left, Nita Sanders, top row left, Odette Robichau (who married the Pee Wee's bakery man) top row 6th from left, Cleo Tatum, 1st row, 2nd from left, Gilbert Adams, 1st row, 4th from left, Hawthorn Broussard, Donated by Nita McKnight." (Courtesy Tyrrell Historical Library.)

The Eastern Texas Electric Company introduced trolley service to Beaumont. A celebration is being held at the interurban terminal beside the building. The next photograph shows much more of the block. (Courtesy Tyrrell Historical Library.)

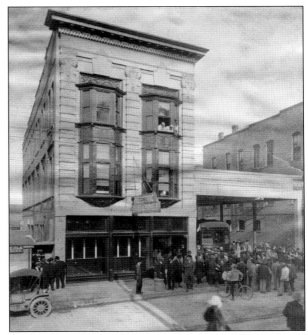

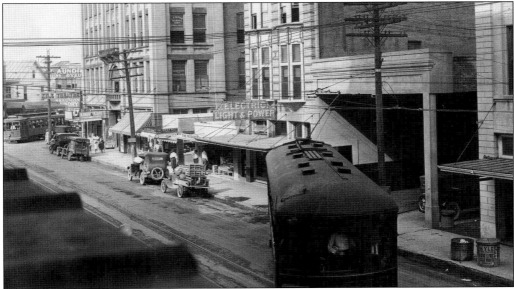

This trolley streetcar is seen in downtown Beaumont about 1915. The Kyle Opera House is the tall building on the far left. The caption reads, "Main Office and Interurban Terminal, Eastern Texas Electric Co. Beaumont, Texas." The sign on the front of the building reads, "Electric Light and Power," and the sign on the trash barrel on the street near the trolley in the foreground reads, "Kyle, Now Playing, Gene Lewis-Olga Worth Company." At the far left, another trolley can be seen turning the corner. Magnification shows the signs on businesses at that end of the block read, "Kyle Theatre," "Beaumont Laundry," "Liberty Cafe," and just to the left of the Electric Light and Power sign, "The Midget Milk Depot," and "The Cozy News Stand." The awning to the left of the Cozy News Stand reads, "Opera Cafe." (Courtesy Tyrrell Historical Library.)

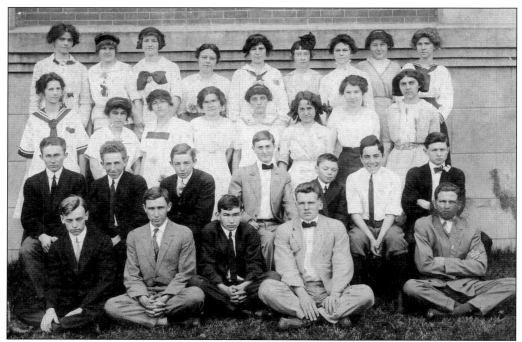

Beaumont High School (BHS) seniors, the class of 1913, are pictured here. Seventeen women and twelve men pose for the class photograph. (Courtesy Tyrrell Historical Library.)

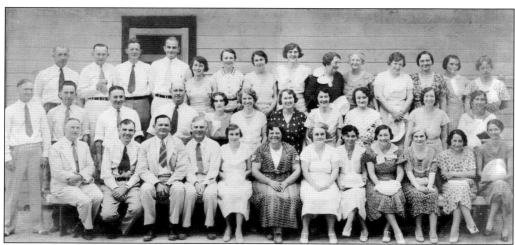

The BHS class of 1913's 20-year reunion at the Enjo Club took place on Village Creek on June 4, 1933. Twenty-four women appear in the reunion picture; however, it is unclear whether they are original classmates that were not in the original class picture or the wives or friends of class members. (Courtesy Tyrrell Historical Library.)

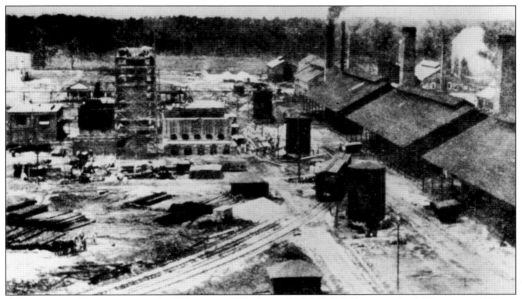

A caption to this picture reads, "This is a 1913 view of Mobil Oil Corporation's Beaumont, Texas refinery, one of the oil industry pioneers. . . . It was . . . built in 1902-1903 following the discovery in 1901 of the great Spindletop oil field south of that city. Originally it covered a mere 89 acres and processed crude oil in batches. The batteries of batch stills operated under the shed-like structures at the right. Today the refinery is the largest in Mobil's worldwide system. It spreads over 1,000 acres and produces a full-line of petroleum products and feedstocks for . . . petrochemical plants. Oil magnate Joseph Cullinan founded the Magnolia Petroleum Co." (Courtesy Tyrrell Historical Library.)

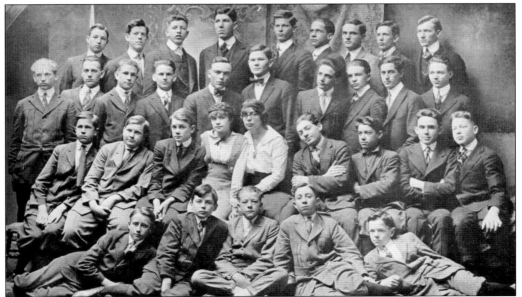

The Beaumont High School Howlers glee club, seen here in 1915, was known for its fanciful nature, as their name indicates, although the members did perform serious work, too. (Courtesy Tyrrell Historical Library.)

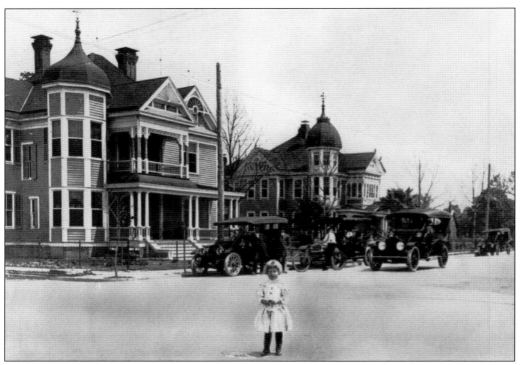

A girl poses in the street with cars parked at the curb. Behind her, gentlemen appear to be dressed for a special occasion. (Courtesy Tyrrell Historical Library.)

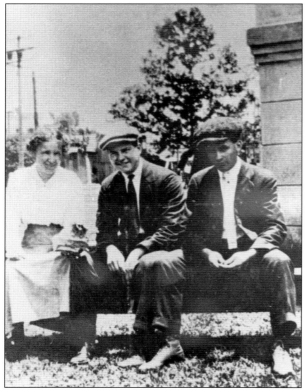

Two men and a lady sit on a bench. The back of the photograph reads, "Caldwell McFaddin Shark Bench 1915." McFaddin, who became successful in oil, rice, and many other business ventures, is in the middle. A shark bench, according to one wag, was where only the coolest men sat to be approached by young ladies, who might then be asked out. (Courtesy Tyrrell Historical Library.)

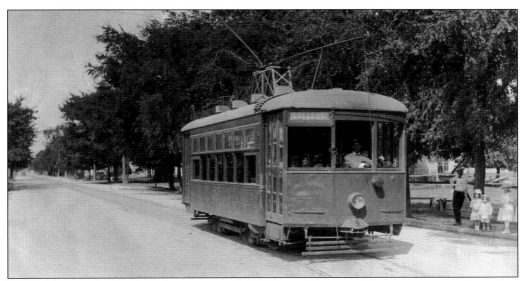

The College Street trolley makes a turn in 1915. The conductor can be seen operating the trolley, and on the side of the street, a man stands with three girls and a boy, who appear to be dressed for a special occasion. (Courtesy Tyrrell Historical Library.)

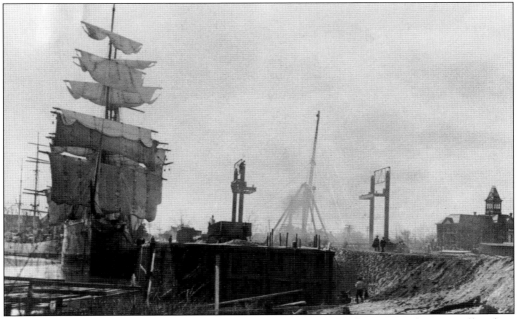

The Port of Beaumont construction took place in about 1915. This image shows a tall sailing ship with full sails, either there for show or in preparation to set sail, as there do not seem to be docking ropes attached. Another sailing ship is in the background with no sails visible. There is construction work on a bulkhead for a dock and poles, along with construction equipment, cranes, men working, men walking along a road, and one man walking down an incline toward the water. The crane seems to be powered by a steam boiler, as there is a puff of steam or smoke around it. In the background to the right is a building said to be the courthouse. (Courtesy Tyrrell Historical Library.)

In downtown Beaumont in about 1913, the Kyle Opera House stands as the tall building at far left, and the building that became the Eastern Texas Electric Company is in the middle with advertisements written on the side. A clock in front of the building reads, "Opera Bar." Trolley tracks are in the brick street, and overhead are electrical and telegraph-telephone lines. (Courtesy Tyrrell Historical Library.)

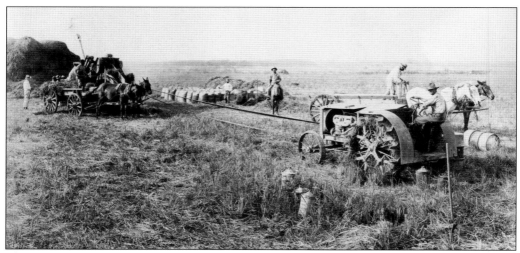

This c. 1915 rice harvest near Beaumont required horses, mules, and mechanical tractors. While the discovery of oil and the industries that supported it became the biggest financial engine in the area, rice, agriculture, and lumber were still important to the economy. (Courtesy Tyrrell Historical Library.)

The Perlstein Building, seen here around 1915, was built at the corner of Pearl and Fannin Streets in 1907 and was, at that time, the tallest building between New Orleans and Houston. It held offices and the S.H. Kress & Co. 5-10-25 Cent Store. The building caught on fire on August 5, 1944, and burned through August 6 in one of the largest and most disastrous fires in Beaumont's history. Firefighters from Orange, Port Arthur, Houston, and the Coast Guard assisted in battling the fire. Every piece of Beaumont's firefighting equipment was used. After the fire, the building was demolished. Today, the Southeast Texas Art Museum stands where it was once located. (Courtesy Tyrrell Historical Library.)

This is the Eastern Texas Electric Company building, the successor to the Beaumont Ice, Light, and Refrigeration Company. The company later became Gulf States Utilities through mergers and acquisitions. The interesting little storefront to the left seems to be a tobacco shop, as the advertisements are for Chesterfield Cigarettes, Bull Durham Tobacco, Fatima, Omar and Nebo Cigarettes, and Osceola Cigars; however, the store also sells apples, potatoes, and other foods. (Courtesy Tyrrell Historical Library.)

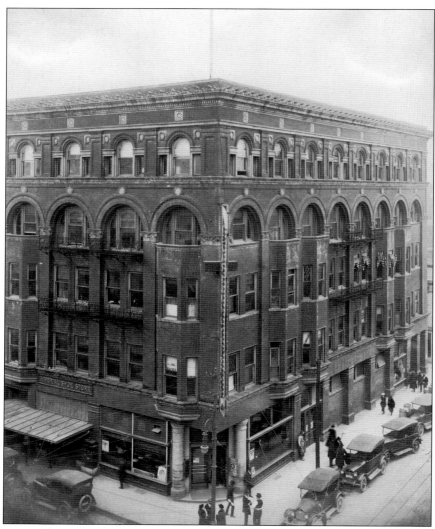

The Wiess Building at 310 Pearl Street, seen here in 1916, was an office building with the Texas Bank and Trust on the first floor and doctors' and dentists' offices, as well as other professional offices. Historian W.T. Block writes in *Beaumont's Fabulous Wiess Brothers: Business Leaders of Early Beaumont*, "For twenty years Valentine Wiess had owned the largest business firm in Beaumont, V. Wiess and Company consisting of a grocery firm, a dry goods firm, [a] hardware and farm implement firm, retail lumber, banking, and insurance firm, and his payroll had begun to compare to that of the sawmill. By 1902, his interests too were beginning to focus on oil. He soon became an early stockholder of the J. M. Guffey Production Co.; he invested in pipe lines, and later teamed up with W. P. H. McFaddin to found the McFaddin and Wiess Oil and Gas Company, headquartered at 302 Tevis Street. In 1913, the year of his death, Val Wiess was the largest taxpayer on the city's tax rolls, having invested heavily in business property and in practically every other enterprise of note within the city. In 1900, he built the first five-story brick building in Beaumont. There seems to be little doubt that, when he died, Val Wiess was the wealthiest of the three brothers, although all fiscal papers have been removed at some time in the past from his probate file and were never returned. At a later date, his daughter donated Wiess Park to the City of Beaumont." (Courtesy of Tyrrell Historical Library.)

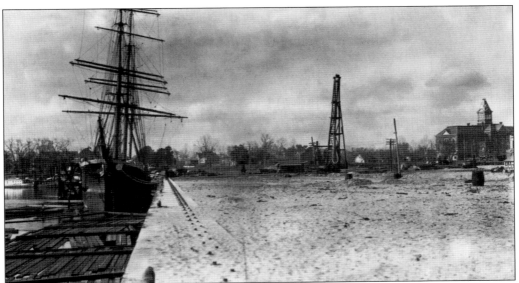

Pictured is the Port of Beaumont, with a sailing ship docked and lumber floating in the Neches River. The old courthouse is visible in the background. (Courtesy Tyrrell Historical Library.)

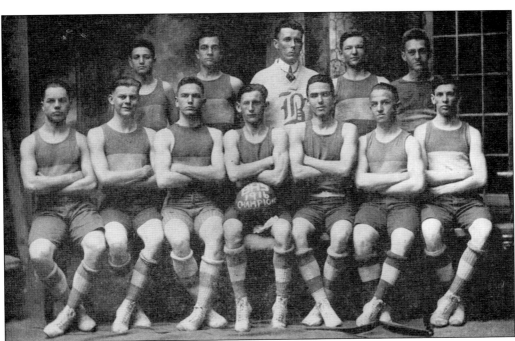

Pictured here is the Beaumont High School Southeast Texas championship basketball team of 1916, as seen in the 1916 *Pine Burr*, the high school's yearbook. (Courtesy Tyrrell Historical Library.)

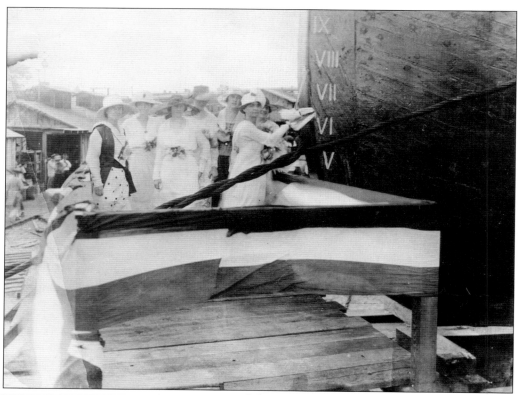

Other important industries thrived beside oil in Beaumont after Spindletop, including shipbuilding. In this photograph taken at the foot of Wall Street during World War I, Mrs. R.J. McBride, wife of the co-owner of McBride and Law Shipbuilding Company, breaks a bottle of champagne on the bow of the first wooden-hulled ship completed there, the *Quapan*, a sea-going tugboat. (Courtesy Tyrrell Historical Library.)

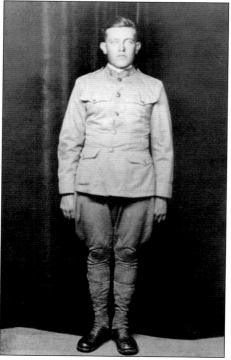

Charles Alexander Norbet is pictured in his World War I military uniform. He was born in 1898 in Illinois, served in the Mounted Engineers in World War I, and is buried in Orange County. (Courtesy Tyrrell Historical Library.)

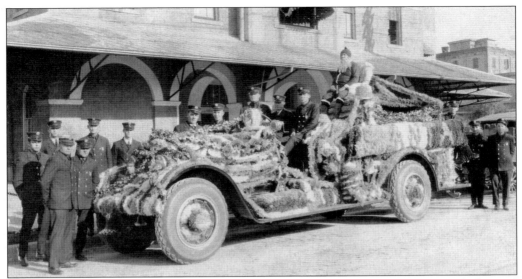

Men in uniform surround a Christmas-decorated fire truck, with Judge J.D. Campbell suited up as Santa. The decorations include paper bells hanging from the front of the truck, garlands stretching over the engine compartment and pumper tank, and Santa's throne. A hand-crank siren is in front of the passenger side of the driver's compartment. The steering wheel is on the right. (Courtesy Tyrrell Historical Library.)

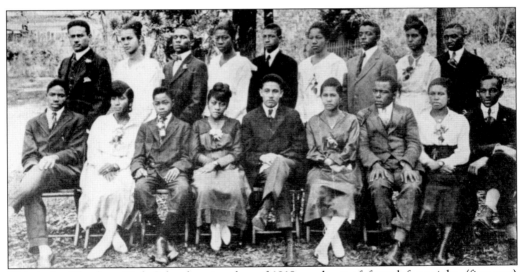

This is the Charlton High School senior class of 1918, made up of, from left to right, (first row) Karl Leslie Anderson, Myrtle Eola Trimble, Morris Rufus Hebert Jr., Elnora Thericia Allen, Andy Sidney Wandless, Aurelia Hearez Patillo, Robert Louis McGowan, Henrietta Almealer Wilierson, and Albert Vonzie Adams; (second row) Prichett Hydal Willard, Gladys Mayetta Wells, Alden Bertruc Thompson, Hazel Helena James, Henry Edward Jones Jr., Nina Armather Heard, John Russell Ratcliff, Maud Estelle Lee, and Grant Ulysses Gibson. The school was named for Charles Charlton, the famed black educator in Beaumont. Charlton was a former slave from Tyler County who helped organize the first black school in Beaumont as well as many other schools. (Courtesy Tyrrell Historical Library.)

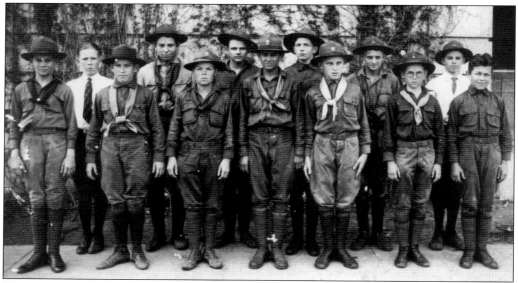

This is a Beaumont Boy Scout troop in 1919. The caption on the back reads, "I judge this picture was made in 1919. My brother, Douglas Hale, is the boy on the back row with his hat cocked to one side. —Signed, Jessamine." (Courtesy Tyrrell Historical Library.)

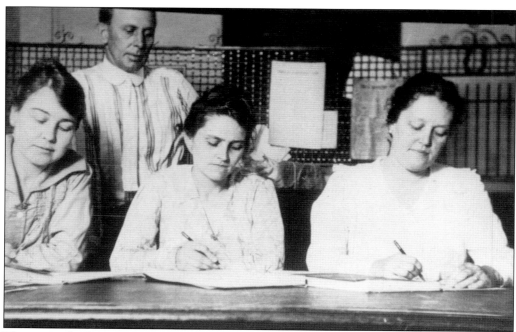

These were the first women in Beaumont to register to vote. They are, from left to right, Mrs. Steve M. King, Mrs. Henry Jirou, and Anna Price Bordages. (Courtesy Tyrrell Historical Library.)

Five

1920 TO 1929

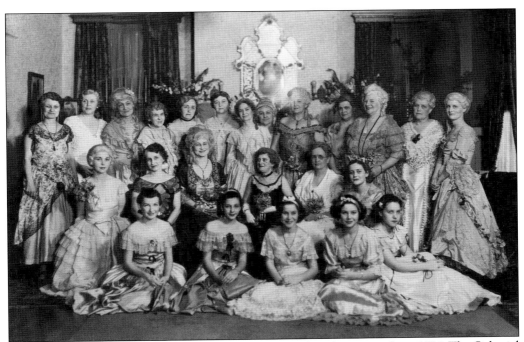

Members of the Colonial Dames of America appear in colonial costume about 1934. The Colonial Dames of America is an American organization composed of women who are descended from an ancestor who lived in British America from 1607 to 1775 and was of service to the colonies by either holding public office, being in the military, or serving in some other eligible way. (Courtesy of Tyrrell Historical Library.)

In 1878, Mark Wiess teamed up with J.F. Ward, H.W. Potter, and W.P.H. McFaddin to found the Reliance Lumber Company, using the land and facilities on Brake's Bayou of the old Wiess and Potter mill as its nucleus. From its beginning, the Reliance mill had a cutting capacity of 50,000 feet daily, unbelievable lumber production for that era, due solely to its "shotgun feed" steam carriage, invented and patented by Mark Wiess because of his frustration with the slow production of a sawmill he owned. According to W.T. Block, author of *Beaumont's Fabulous Wiess Brothers*, it was the only sawmill in the world that was so equipped at that time. (Courtesy of Tyrrell Historical Library.)

Beaumont's Permanent Italian Marching Band, pictured in 1920, added color and culture to the local social scene. (Courtesy of Tyrrell Historical Library.)

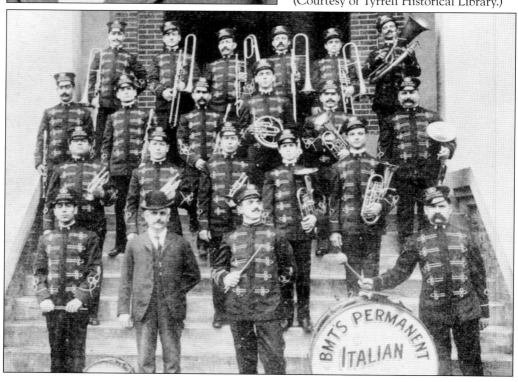

Instant message delivery was different in 1920. This is Floyd Nichols in his Western Union uniform with his delivery bicycle. (Courtesy of Tyrrell Historical Library.)

Socialite Vallie Fletcher (left) is pictured in a scene at rice harvest time in 1920. (Courtesy of Tyrrell Historical Library.)

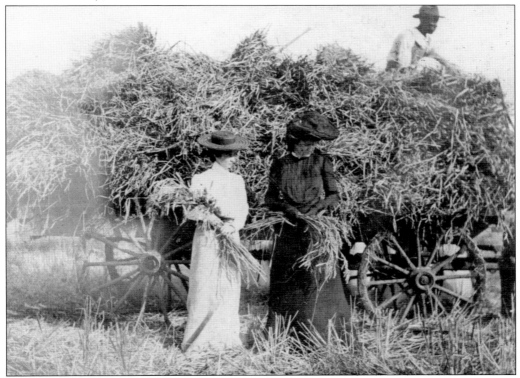

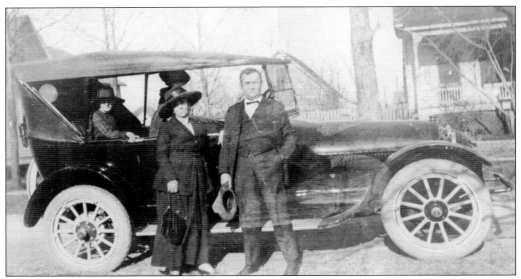

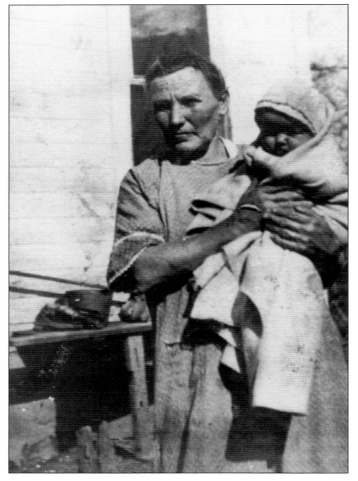

Ernest L. Nall and his wife, Lola (née Rockford), are seen here in a photograph captioned, "New Car with Momma, Papa and Kids." The caption was written by one of the children and the car was a Buick Cabriolet. (Courtesy of Tyrrell Historical Library.)

Agnes Norhuntos and a child are seen in a 1920 photograph depicting the reality of working-class life. (Courtesy of Tyrrell Historical Library.)

Distinguished educator Charles Charlton was the black Beaumont educator for whom Charlton School was named, which later became Charlton-Pollard High School. (Courtesy of Tyrrell Historical Library.)

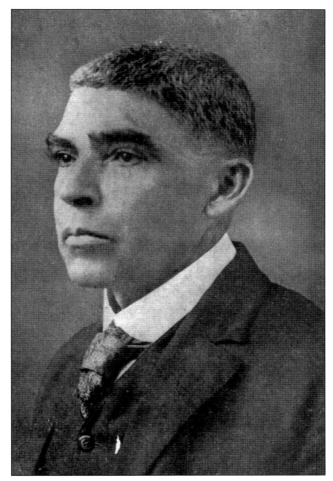

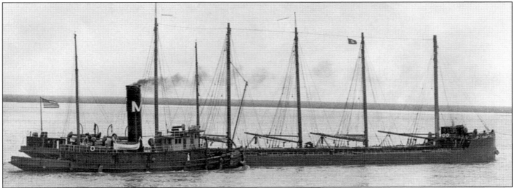

The tugboat *George C. Greer*, a Magnolia Petroleum Co. tug, is seen here towing the five-masted barge *Socony* No. 14 at Fort Point at Sabine Pass, Texas. The *Socony* was one of the first barges for what became Mobil Oil, and there were multiple tanker ships later named *Socony* (Standard Oil Company of New York). The *Socony* and *Vacuum* (Vacuum Oil Company of New York, founded about 1866) were ships representing the two founding companies of Mobil at various times. (Courtesy of Tyrrell Historical Library.)

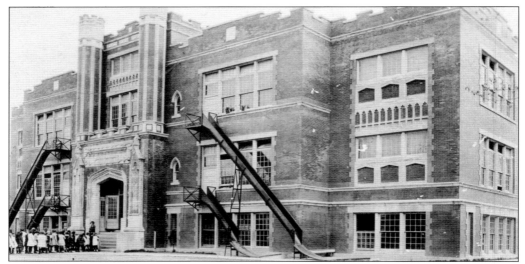

A Beaumont elementary school in the 1920s shows prominent slide fire escapes on the front of the building from the second and third floors. A distinctive facade and brickwork accent the building from bottom to top, and an interesting entry with what appears to be chimneys make the building attractive. A teacher is at the entrance steps, waiting for her class to come inside. (Courtesy of Tyrrell Historical Library.)

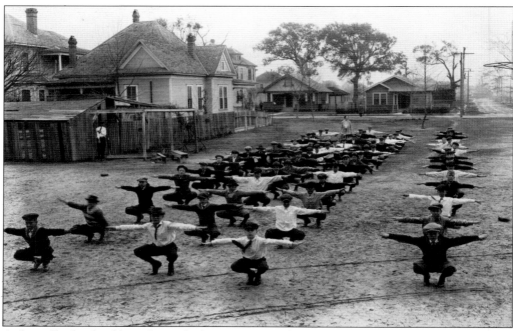

A class of high school boys does calisthenics, apparently in a schoolyard that abuts neighborhood houses. (Courtesy of Tyrrell Historical Library.)

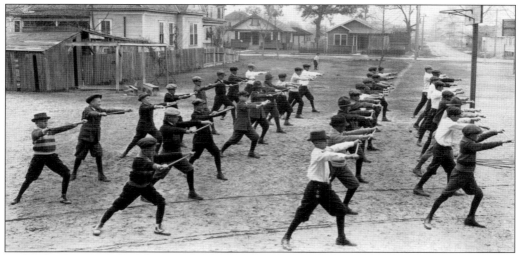

High school or junior high boys perform calisthenics with exercise sticks. Almost all wear knickers and either coats or sweaters and hats; some appear in sporty shoes. All the boys seem to be seriously working on their exercises for the photograph, with the exception of a boy second from the left in the back row, who seems to be sharing a joke with the boy in the row in front of him, third from the left. (Courtesy of Tyrrell Historical Library.)

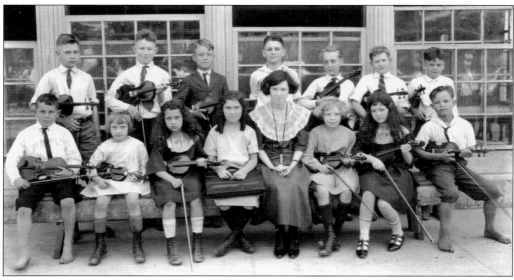

Boys and girls in violin class pose with their teacher at Pennsylvania Elementary School. Each child's expression is very different. The two boys on either end of the first row with no shoes on seem to be ready to go play. (Courtesy of Tyrrell Historical Library.)

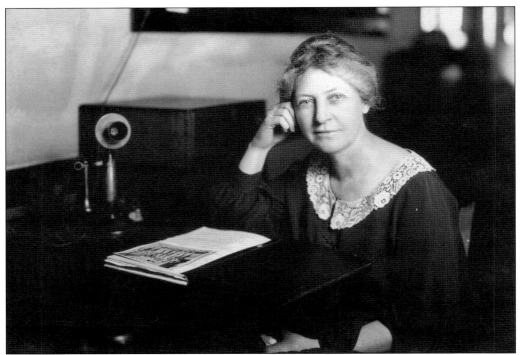

This woman is in a school office. Note the telephone and the picture of basketball players in front of her. (Courtesy of Tyrrell Historical Library.)

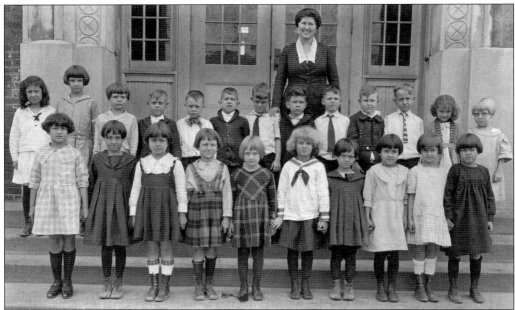

In this class picture at Pennsylvania Elementary School, there are nine boys and fourteen girls. At least one of the boys may have been a handful, as his teacher's hand seems to be on his shoulder to assure him of her presence. Some of the girls in front hold hands. (Courtesy of Tyrrell Historical Library.)

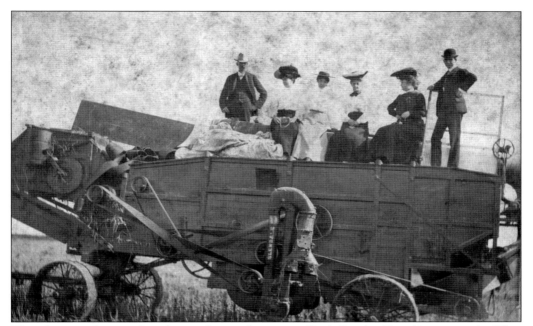

This photograph was taken during the rice harvest at Keith-Dowlen Rice Farm near the West Beaumont oil field. Dressed-up men and women sit and stand atop a wagon of rice. (Courtesy of Tyrrell Historical Library.)

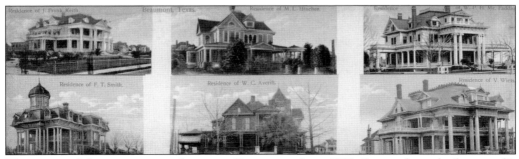

This postcard shows prominent homes in Beaumont about 1920. Featured are the homes of J. Frank Keith, M.L. Hinchee, W.P.H. McFaddin, F.T. Smith, W.C. Averill, and V. Wiess. Most of these homes have been torn down. (Courtesy of Tyrrell Historical Library.)

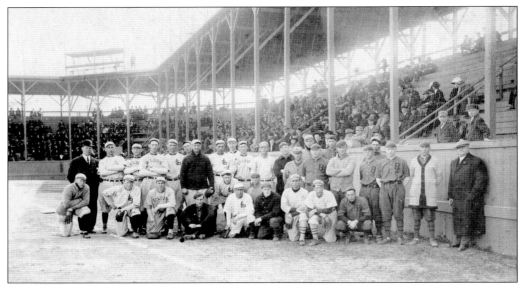

Edward Stedman, born in 1875, is at far right in the long coat at Beaumont's Stuart Stadium. This was apparently at an exhibition game, as the players' uniforms have the "StL" logo for St. Louis or "St. Louis," and some just have a "B," perhaps for Beaumont. (Courtesy of Tyrrell Historical Library.)

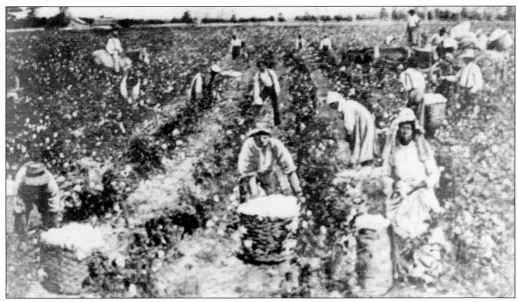

This is what cotton picking looked like in the 1920s. The scene was in northeast Beaumont near what is now Parkdale Mall. (Courtesy of Tyrrell Historical Library.)

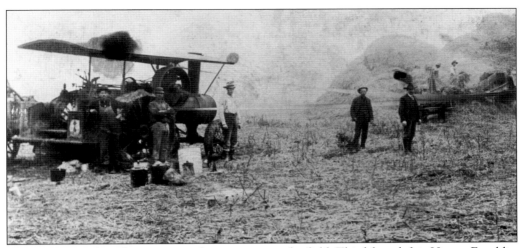

This is a scene of rice harvesting with equipment in the field. Third from left is Homer Franklin Walker, and the man on the far right is John Pruitt Walker. Homer Franklin Walker had invented and patented machinery for the cutting of the ends of the rice sheaves, which made harvesting and handling much easier and faster. (Courtesy of Tyrrell Historical Library.)

The *Magpetco* magazine was published by Magnolia Refining Company. At the bottom of the text, the name of the magazine is explained as follows: "The Committee appointed to select a name for the new plant publication were: J.W. Newton, C.S. Dickens, E.E. Swope, T.E. Schley and N.H. Lee. About 200 names were suggested. The name finally selected was 'The Magpetco.' This name was suggested by Mr. S.A. Hensley, Yardmaster, who was awarded the prize of $5.00. The word Magpetco is composed of the first three letters of Magnolia, the first three letters of Petroleum, and the first two letter of Company." (Courtesy of Tyrrell Historical Library.)

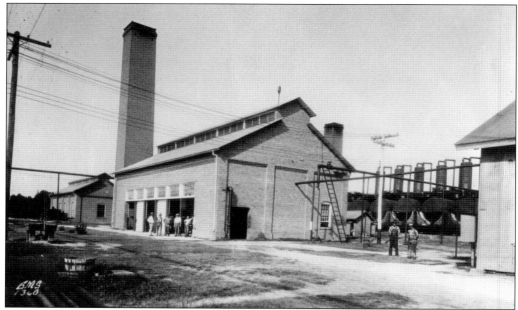

By the 1920s, the Magnolia Refining Company had a substantial powerhouse to produce the power needed to run the plant. (Courtesy of Tyrrell Historical Library.)

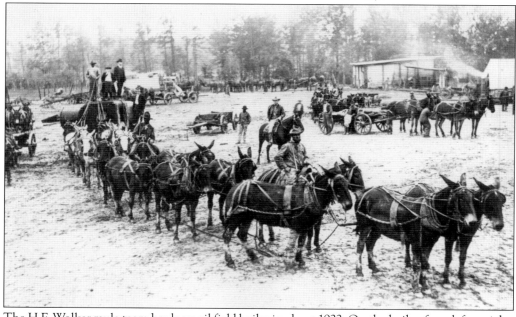

The H.F. Walker mule team hauls an oil field boiler in about 1922. On the boiler, from left to right, are an unidentified mule skinner, Johnnie Walker (age 12), and Homer F. Walker. The team was strung two abreast (two-ups) because the oil field roads were too narrow for four or more mules to work side by side. This is a sixteen-up (eight two-ups). Everything worked just fine until they reached a turn in the road, and then the mules had to become fancy steppers, having to step over the pull chain, as it followed the shortest distance between the lead mule and wagon. (Courtesy of Tyrrell Historical Library.)

William P. Hobby, pictured here in about 1920, was the publisher and owner of the *Beaumont Enterprise* from about 1907 to about 1914, when he was first elected lieutenant governor of Texas. Later, he became the governor of Texas, serving during World War I. After completing two terms in office, he returned to the *Beaumont Enterprise*, the morning newspaper, and also acquired the *Beaumont Journal*, the evening paper. He and his family went on to further newspaper, radio, and television business prominence in Houston, with Houston's first commercial airport being named after him. (Courtesy of Tyrrell Historical Library.)

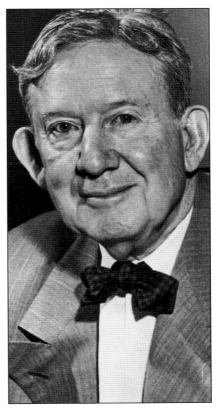

In this 1922 photograph, a Beaumont Traction Company trolley car appears to carry four riders: one man in the rear, a child and adult in the middle, and a lady in a hat. Two men can be seen at the rear of the trolley, along with two men in front; they are apparently conductors or attendants. (Courtesy of Tyrrell Historical Library.)

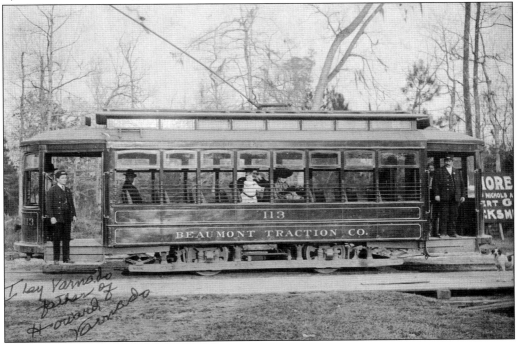

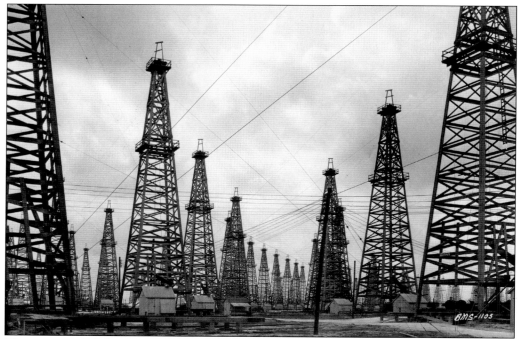

The maturity of the Spindletop field can be seen in this photograph of wooden derricks, each with its own maintenance shed. Dirt roads ran through the area. (Courtesy of Tyrrell Historical Library.)

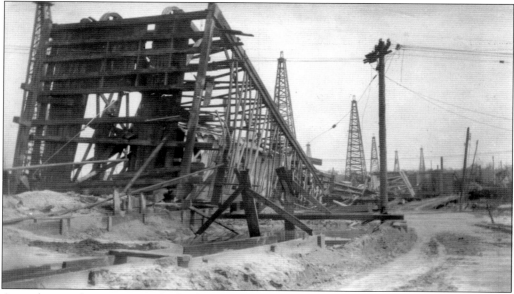

According to the writing on the back of the postcard, this rare picture shows a "112 foot derrick blown down by a cyclone on March 30, 1926 at Spindletop, 3 miles South of Beaumont." The derrick seems to have fallen over a nearby building, breaking out the side of the derrick but leaving the building largely intact. More than one building may have been involved. (Courtesy of Sam Houston Regional Library, Liberty, Texas.)

Damage from a cyclone on March 25, 1922, is surveyed by young men walking on fallen roofs. Note the little girl on the right and the man on the pole at far left. People and intact houses are in the background. (Courtesy of Tyrrell Historical Library.)

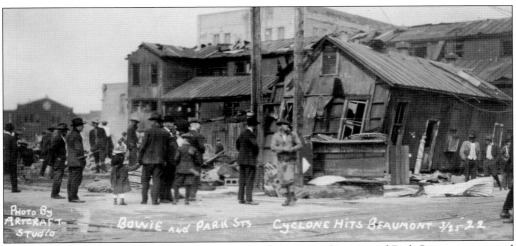

Damage from the March 25 cyclone downtown at the corner of Bowie and Park Streets is surveyed by the townspeople. (Courtesy of Tyrrell Historical Library.)

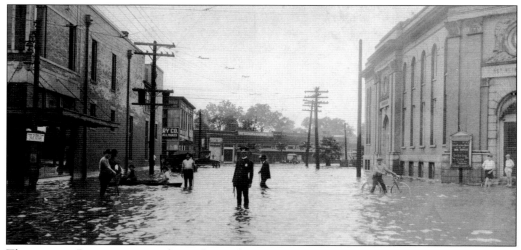

The rains in Beaumont caused significant damage at Pearl Street and Calder Avenue. This is a flooded street scene at Broadway Avenue looking west on May 18, 1923, with a policeman at center. A man can be seen behind the light pole on the left, and two men are in a boat. Others wade through the calf-deep water, while one bicyclist seems bogged down, or at least has stopped for the picture. On the right, two boys have rolled up their pants legs and enjoy the water. The church notice board at First Methodist Church reads, appropriately, "Bon Voyage." In the background, a car braves the water. (Courtesy of Tyrrell Historical Library.)

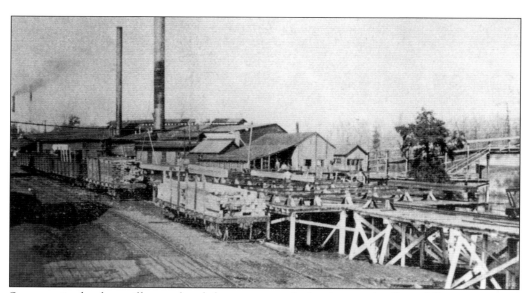

Seven major lumber mills populated the area around what is now the Port of Beaumont using the Neches River to bring logs from the pine forests. Pictured here is a Beaumont lumber mill as it appeared in 1924. (Courtesy of Tyrrell Historical Library.)

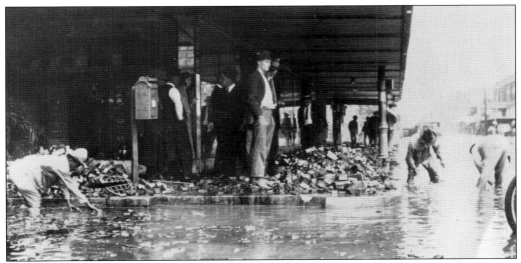

According to the back of this photograph, "The first paving blocks of the downtown streets were of wood. They were durable and extra quiet when in place. The only trouble was when a flash flood came they floated out and had to be picked up and put back in the street as can be seen here. The main trouble with this was that the blocks made excellent kindling and firewood and after every flood there were fewer blocks to put back." On the night of May 17, 1923, Beaumont received 13.5 inches of rain in two hours. The rainfall was the heaviest in the area since records had been kept. Recordings in Beaumont show that the Neches River rose 11 feet overnight. Many buildings and houses received heavy damage, with repair estimates reaching almost a million dollars. Area streets were closed as wooden paving blocks were carried away with floodwaters. (Courtesy of Tyrrell Historical Library.)

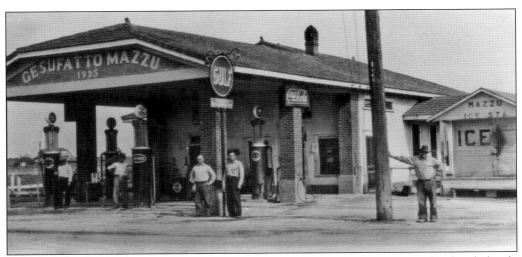

This is the landmark Mazzu's Gulf service station, located on the corner of Highland and Florida Streets. Pictured from left to right are Bill Mazzu, Jess Mazzu, Vincent Madaffri (son-in-law to Giosofatto Mazzu, the patriarch), Sylvester Mazzu, and owner Giosofatto Mazzu. (Courtesy of Marilyn Mazzu McClory collection.)

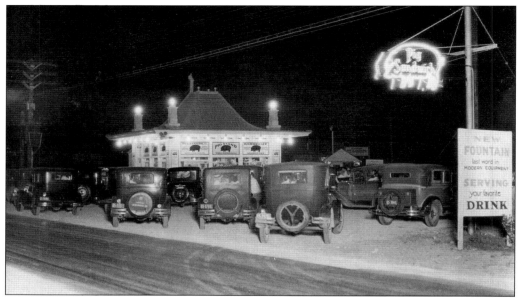

The Pig Stand, seen here on the corner of Railroad and Highland Avenues in about 1927, "was where you took your girlfriend to show her off or where you went by to see who was dating your girl when you were not looking," according to the caption on the back. It was the watering hole for the Lamar College crowd. Waiters were called carhops, because the first one to jump on the running board of a car got to take the order. Carhops may not be seen here, but the Pig Stand was famous for them. Closer inspection shows numerous people in each car and at least one person, possibly a carhop, visiting at the window of one car. (Courtesy of Tyrrell Historical Library.)

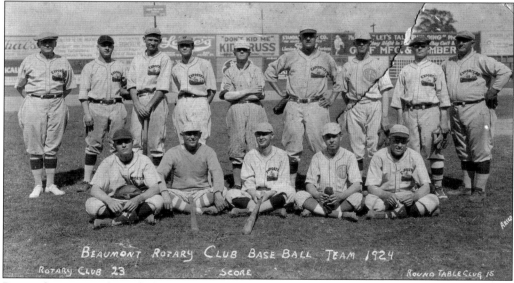

Pictured are 14 uniformed players inside a fenced stadium bounded by Magnolia, Grand, Hazel, and Long Streets. (Harrison Street did not exist between Hazel and Grand Streets at that time.) Two uniforms are monogrammed with "BHS" (probably for Beaumont High School), two are blank, and the others say "Exporters," a minor league professional team. (Courtesy of Tyrrell Historical Library.)

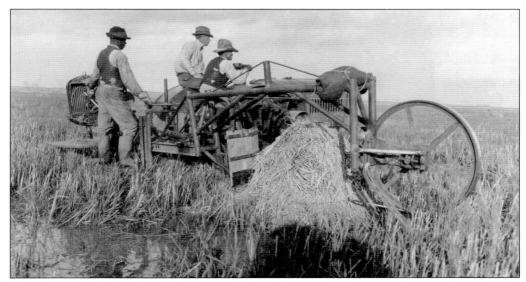

Homer Walker, Robert Beard, and an unidentified man at left operate a butt-cutting machine during this 1925 rice harvest. The machine, used to cut and separate the butts of rice after they were shocked, was patented by Homer Walker in 1927. (Courtesy of Tyrrell Historical Library.)

J.J. Vincent and his wife sit aboard Collier's Ferry, located at the foot of Pine Street and the Neches River near the Beaumont County Club. The site of Collier's Ferry was originally a river crossing point on the Opelousas Trail that went from Liberty through Beaumont and into Louisiana, following Indian trails. Cattle were led across the river by lead cows or steers, sometimes by an adventurous human swimmer (as in the tale of Sterling "Strong" Spell, recorded by Beaumont historian W.T. Block) who swam ahead and showed the way. The ferry, which operated from about 1830 through 1950, was a hand-pulled ferry for most of that time. (Courtesy of Tyrrell Historical Library.)

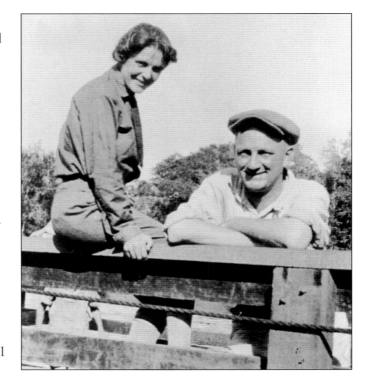

The Jefferson Theatre, built in 1927, was the grand theater in Beaumont for many years. It still hosts special events today. (Courtesy of Tyrrell Historical Library.)

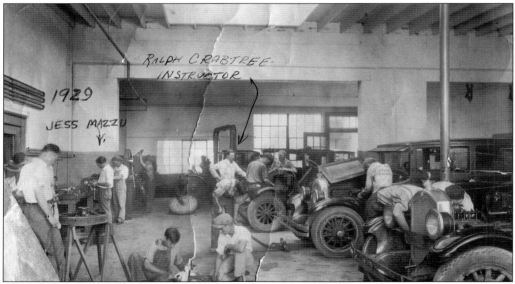

South Park Trade School taught mechanics and other trades. In this 1929 photograph, senior student Jess Mazzu and other students work on cars and equipment as instructor Ralph Crabtree supervises. Both cars being worked on in the foreground are Buicks. This picture shows the transition in equipment, as the wheels continue the use of wooden spokes. They eventually transitioned to metal spokes, solid metal discs, and for a while, wire spoke wheels. (Courtesy of Marilyn Mazzu McClory.)

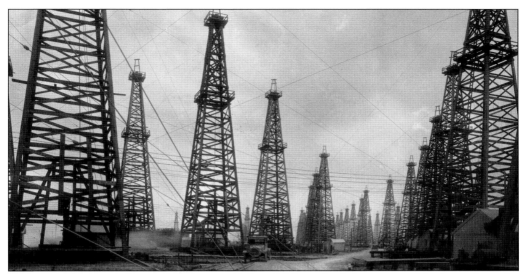

In 1925, Miles Frank Yount, T.P. Lee, and Marrs McLean had the vision of finding oil on the flanks of Spindletop, and on January 13, 1926, the Yount-Lee McFaddin gusher No. 3 came in, causing a second Spindletop boom. This is a scene of completed oil wells at Spindletop in 1929. Three automobiles can be seen along the road. A forest of oil derricks is surrounded by pipes and guy wires, along with support buildings for oil drilling and production. One derrick in the front has a sign that reads, "Yount-Lee Oil Co McFaddin-Wiess-Kyle No. 23." (Courtesy of Tyrrell Historical Library.)

This is an aerial photograph of Stuart Stadium, the minor league baseball stadium located in the South Park area between Avenue A and Avenue B, close to Euclid Street and South of Washington Boulevard. Just south of the stadium are cultivated fields, and the surrounding neighborhood shows how the stadium was part of the community. (Courtesy of Tyrrell Historical Library.)

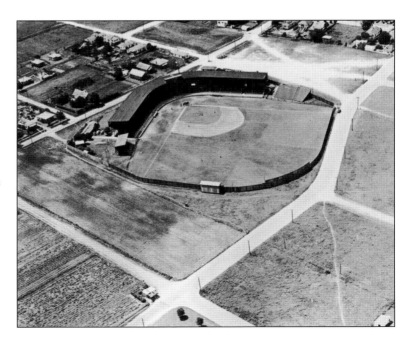

From left to right, Lillian Forster, Marguerite Forster, and Augusta Forster are on a family outing in about 1928. Marguerite has a teddy bear in her lap, and her coat is trimmed with fur on the collar and cuffs. (Courtesy Linda Segrest Brown.)

Jake Ableman's Saddlery began as a leather saddle and tack store, but around the 1920s, Ableman tried his hand at combining his leather craft with automobile repair, as automobiles were changing the economy. He later went back to leatherwork only, as some Beaumonters remember, at his location on North 11th Street, Highway 69 near Voth, just south of the Lower Neches Valley Authority canal. (Courtesy of Tyrrell Historical Library.)

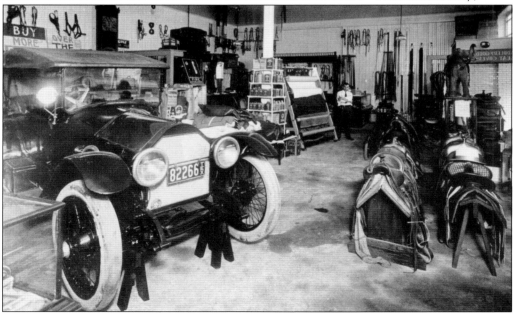

Six

THE 1930S

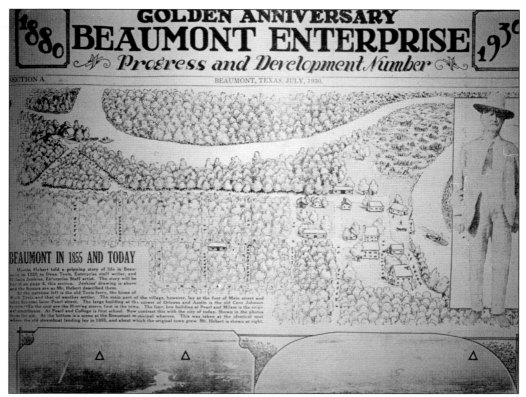

The *Beaumont Enterprise* published the Golden Anniversary issue in July 1930, reflecting life from 1880 to 1930, with mention of the beginnings as early as 1855. According to the front page, "Martin Hebert told a gripping story of life in Beaumont in 1855 to Dean Tevis, Enterprise staff writer, and Holmes Jenkins, Enterprise Staff artist." The artist's rendering of the settlement in 1855 was on the front page with photographs of the city in 1930 below. The oral history by Hebert, who came to Beaumont in 1855, appeared on page four of that section. (Courtesy of Tyrrell Historical Library.)

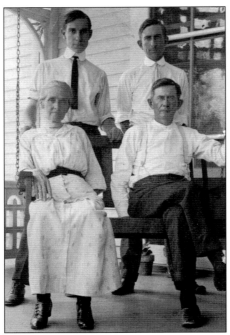

This picture of the Carroll family is labeled "The Unbeaten," because the family had suffered some reversals but persevered in their integrity. From left to right are (seated) Underhill Carroll and George W. Carroll; (standing) Charles Carroll and William Carroll. (Courtesy of Tyrrell Historical Library.)

This is the entrance to the Magnolia Petroleum Company offices and refinery in about 1930. The refinery became one of the most important employers and economic forces in the area. Tracing its history to the Spindletop, the refinery was built in 1903 for the oil coming from Spindletop. Magnolia became Mobil and is now ExxonMobil. (Courtesy of Tyrrell Historical Library.)

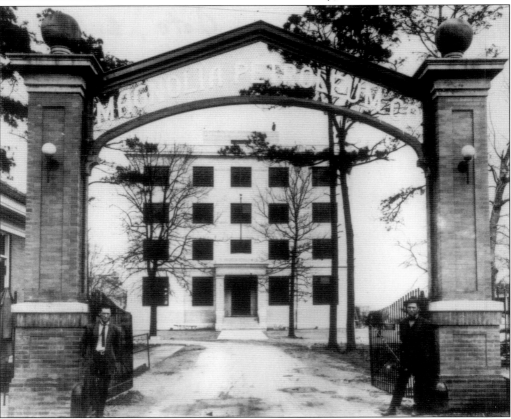

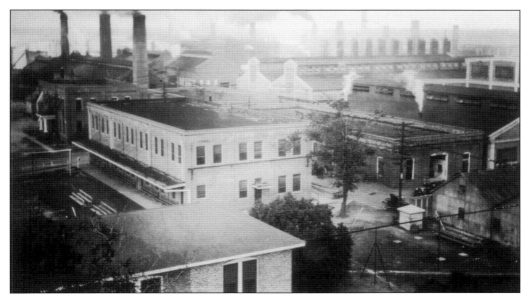

The Magnolia Refining Company had refining units operating and support buildings within the plant. A car, an ambulance or service vehicle, and a horse-drawn wagon are at center, just to the right of the white two-story building. (Courtesy of Tyrrell Historical Library.)

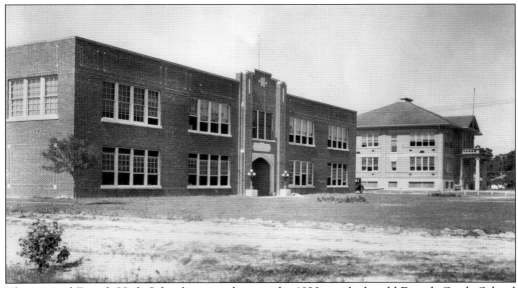

The original French High School appears here in the 1930s, with the old French Grade School on the right. The high school was later rebuilt, and the elementary school became Eugene Field Elementary. (Courtesy of Tyrrell Historical Library.)

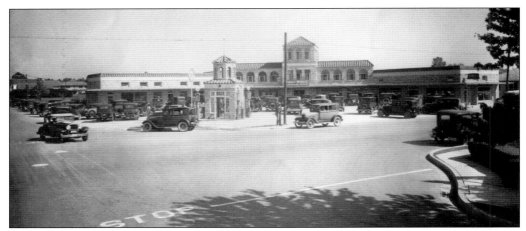

A new shopping center opened in the 1930s at Calder Avenue and 10th Street with a Piggly Wiggly supermarket, a Texaco service station on the corner, a Rettig's Ice Cream parlor, and other stores. Cars are in the streets and in the parking lot, and houses can be seen in the background. This was one of Beaumont's first suburban shopping centers. (Courtesy of Tyrrell Historical Library.)

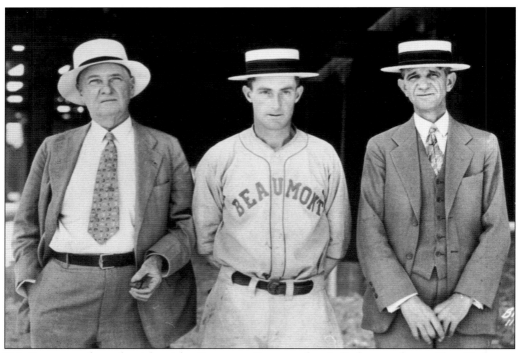

R.L. Stuart stands on the right with a Beaumont Exporters baseball player and an unidentified man. Stuart built the Exporters' stadium, which was located in South Park, just south of Washington Boulevard. (Courtesy of Tyrrell Historical Library.)

Jess Mazzu stands with his motorcycle. He was the son of Giosofatto Mazzu, who owned Mazzu's Gulf service station. (Courtesy of Marilyn Mazzu McClory collection.)

This aerial view of downtown Beaumont in the 1930s shows Harbor Island and the original Kansas City Southern Neches River Bridge near the courthouse, with the Southern Pacific Railroad Bridge in close proximity to the tallest building on the left. (Courtesy of Tyrrell Historical Library.)

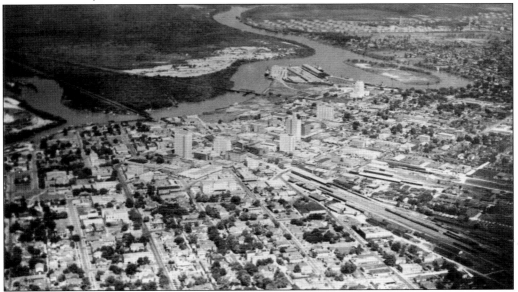

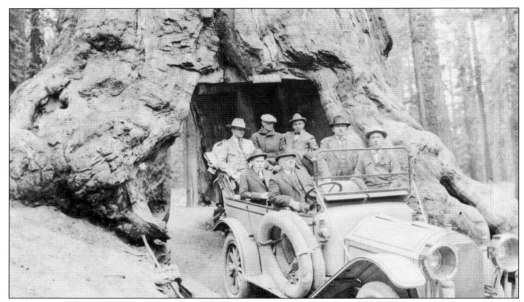

Stuart R. Smith moved to Beaumont just before the Spindletop gusher blew in 1901 and established a law practice, as well as becoming a force in politics. Here, he drives six men and himself through the huge Wawona Redwood tree at Yosemite National Park in California in the Mariposa Grove of Big Trees. (Courtesy of Tyrrell Historical Library.)

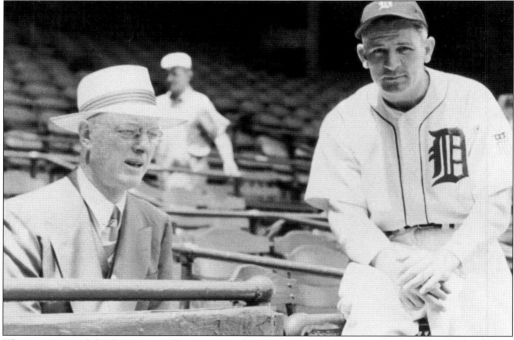

The manager of the Beaumont Exporters in the 1930s was Al Vincent Sr. (right), who had been a minor league player and went on to become a coach and manager in the minor leagues and major leagues. He coached the Lamar University baseball team from 1974 to 1989. The man on the left is Jack Zeller. (Courtesy of Tyrrell Historical Library.)

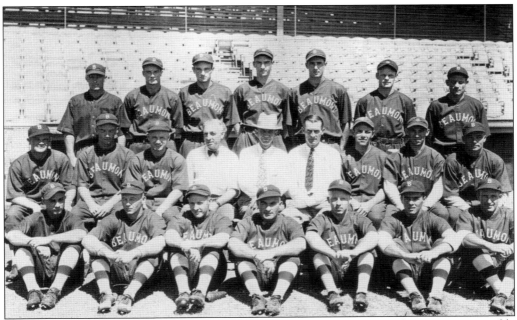

This 1934 Beaumont Exporters team photograph features "Rube" Stuart in the center, presumably in the white hat. The Exporters were a minor league affiliate of the Detroit Tigers from 1920 to 1949 and again from 1953 to 1955. Stuart was the builder of Stuart Stadium, where the team hosted games. (Courtesy of Tyrrell Historical Library.)

Mildred "Babe" Didrikson Zaharias, born in Port Arthur on June 26, 1911, moved with her family to Beaumont at age four. She is considered one of the greatest women athletes of all time. She set Olympic and world records in track and field events and won the 1932 Amateur Athletic Union woman's track championship as the sole entry of her team. She excelled in basketball, baseball, swimming, diving, archery, and golf, and was the first woman to play on the PGA with professional men. She helped found the LPGA and won an astonishing 14 tournaments in a row and a total of 82 tournaments. (Courtesy of Tyrrell Historical Library.)

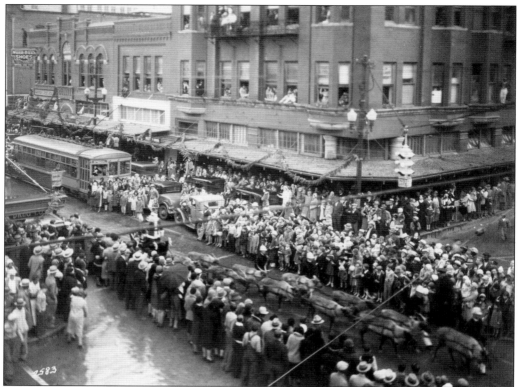

This is the famous Christmas parade when Santa Claus came to town with his reindeer in 1935, as seen at the corner of Pearl Street and Liberty Avenue. Many people line the streets several persons deep despite the rain, and some watch from the windows of buildings decorated with garlands. A man at far left seems to have climbed a ladder to stand on top of the Nunn Bush Shoes sign. (Courtesy of Tyrrell Historical Library.)

Collier's Ferry, a hand-drawn ferry at the foot of Pine Street next to the Beaumont Country Club, operated from 1831 to 1950. It was the main crossing of the Neches River on the Opelousas Trail from Liberty through Beaumont to Louisiana. Cattle herds came to the landing north of Beaumont. (Courtesy of Tyrrell Historical Library.)

Two boys pose with a pet sheep at a service station, which has signs advertising Mobil oil, Humble gas and oil, and Goodrich tires. (Courtesy of Tyrrell Historical Library.)

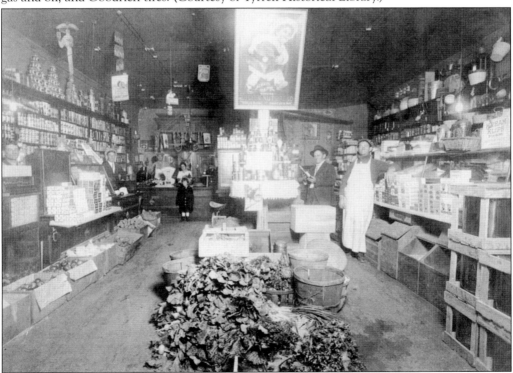

The interior of a grocery store in the 1930s shows an ad for Butter-Nut Bread, baked in Beaumont. Local farmers' produce was popular, as many homes still had their own gardens and raised much of their own food. (Courtesy of Tyrrell Historical Library.)

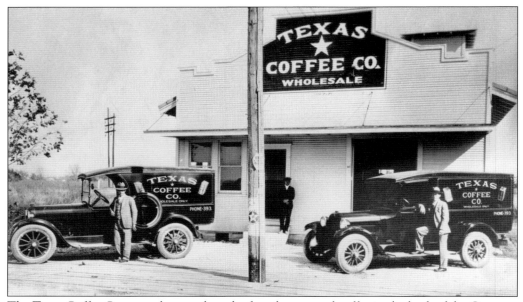

The Texas Coffee Company began when the founders roasted coffee in the back of the Crescent Market grocery store. Soon, coffee was much more popular and profitable than anything else, so the company expanded and moved to this location. (Courtesy of the Joseph Fertitta family collection, Texas Coffee Company.)

Beaumont has always been known for the rice produced in the surrounding area, and the Comet Rice plant took advantage of the abundant supply to produce rice ready for kitchen use. Here, workers load boxes of Comet Rice into a vessel for processing before shipping to customers. (Courtesy of Tyrrell Historical Library.)

The J.H. Phelan Building was located at 520 Magnolia Street at Calder Avenue. It was designed by Stone and Pitts Architects and built by Seymore Construction Company with steel by Dollinger. Signs on the building read Phelan Building, Calma Store, and Collins Pharmacy No. 3, and there are ads for yams, roast, P&G (Proctor and Gamble) soap, and stew meat. A Mobil service station is in the parking lot. (Courtesy of Tyrrell Historical Library.)

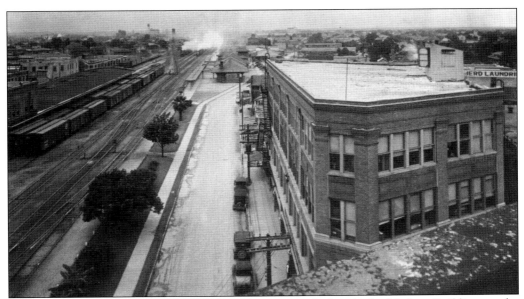

In the 1930s, the Southern Pacific Railroad lines ran right beside the Nathan Building on the north end of downtown. Today the railroad tracks are gone, replaced by streets, but the building remains. (Courtesy of Tyrrell Historical Library.)

DISCOVER THOUSANDS OF LOCAL HISTORY BOOKS
FEATURING MILLIONS OF VINTAGE IMAGES

Arcadia Publishing, the leading local history publisher in the United States, is committed to making history accessible and meaningful through publishing books that celebrate and preserve the heritage of America's people and places.

Find more books like this at
www.arcadiapublishing.com

Search for your hometown history, your old stomping grounds, and even your favorite sports team.

Consistent with our mission to preserve history on a local level, this book was printed in South Carolina on American-made paper and manufactured entirely in the United States. Products carrying the accredited Forest Stewardship Council (FSC) label are printed on 100 percent FSC-certified paper.

MADE IN THE
USA